E. Gabbay was born in Tehran, Iran. He had an interest in art from a young age and was inspired by graphic designer Victor Vasarely. At the age of 17, he enrolled in an art studio to learn oil painting on canvas.

He moved to the United States in 1978 to attend university. During his college years, he took classes in geometric design, acrylic painting, and sculpture. He created abstract, landscape, and geometric designs. Later he refined his style into a combination of surrealism and mysticism with a Judaic point of view.

He also got inspiration from American artists of the 1800s who attended 'The Hudson School of Art', including Thomas Cole, Fredrick Church, Robert S. Dickinson, and Albert Bierstadt. He reproduced their work to learn their style and later put his own twists on the works.

Within the last fifteen years, he has gotten his inspiration from the works of Schim Schimmel, an environmentalist and conservationist.

ILLUSTRATIONS AND INSIGHTS FROM THE OLD TESTAMENT:

A Coffee Table Book

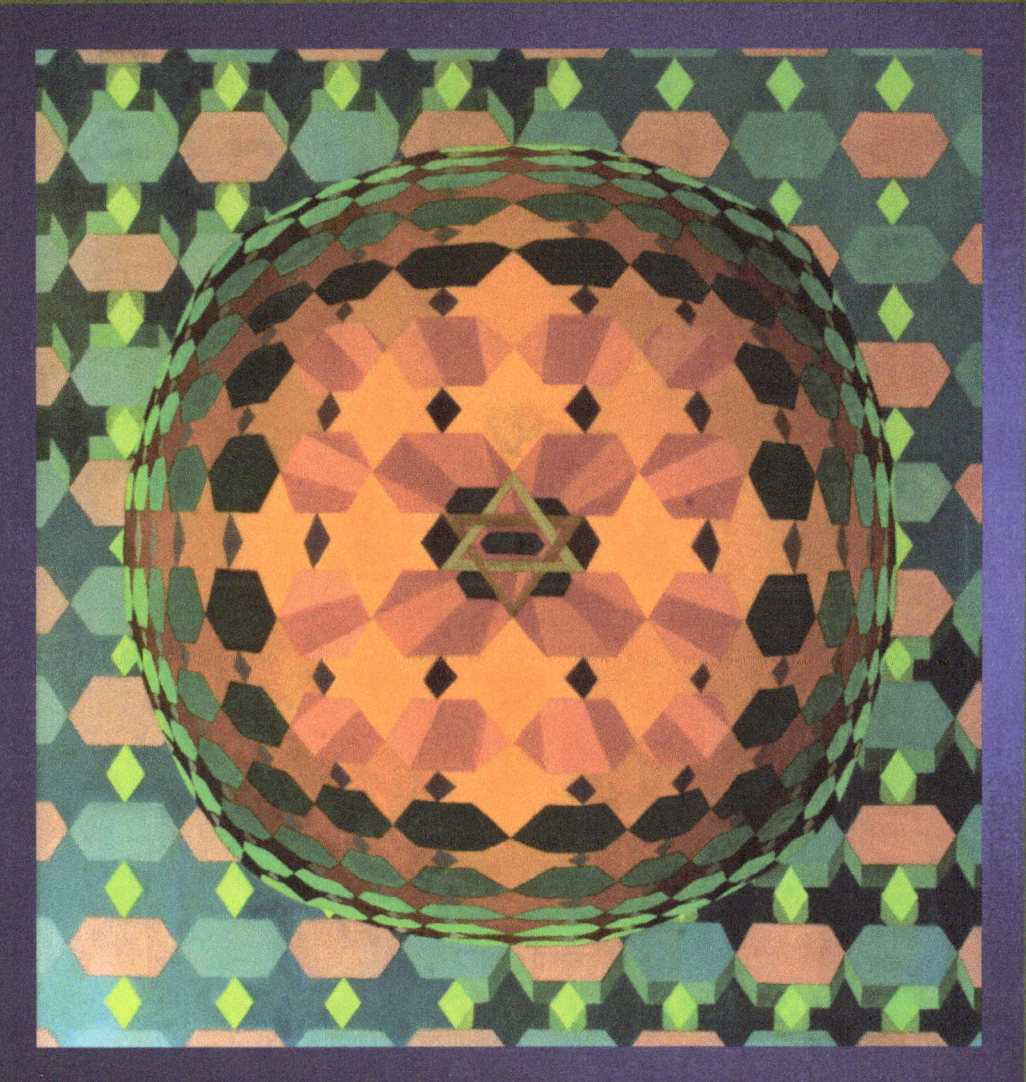

E. Gabbay

Austin Macauley Publishers
LONDON · CAMBRIDGE · NEW YORK · SHARJAH

Copyright © E. Gabbay (2021)

All rights reserved. No part of this publication may be reproduced, distributed, or transmitted in any form or by any means, including photocopying, recording, or other electronic or mechanical methods, without the prior written permission of the publisher, except in the case of brief quotations embodied in critical reviews and certain other non-commercial uses permitted by copyright law. For permission requests, write to the publisher.

Any person who commits any unauthorized act in relation to this publication may be liable to criminal prosecution and civil claims for damages.

Ordering Information
Quantity sales: Special discounts are available on quantity purchases by corporations, associations, and others. For details, contact the publisher at the address below.

Publisher's Cataloging-in-Publication data
Gabbay, E.
Illustrations and Insights from the Old Testament: A Coffee Table Book

ISBN 9781645752646 (Paperback)
ISBN 9781645752653 (Hardback)
ISBN 9781645752660 (ePub e-book)

Library of Congress Control Number: 2020925271

www.austinmacauley.com/us

First Published (2021)
Austin Macauley Publishers LLC
40 Wall Street 33rd Floor, Suite 3302
New York, NY 10005
USA

mail-usa@austinmacauley.com
+1 (646) 5125767

First of all, I dedicate this book to my late father who always supported me and taught me to live moderately, to be optimistic, enjoy every day, and to learn something from every person I meet. Next, I dedicate this to my granddaughter and to all the children, teens, young adults, and adults of the next generations who will inherit our beautiful Earth.

I thank God, who provided me with the vision and the circumstances to create these works of art. I also acknowledge religious authors whose works have inspired me to create. I thank all the rabbis and religious scholars for their weekly sermons that have expanded and developed my vision. I especially want to thank my beautiful wife, who always believed in me and my vision. She always supported my artistry and gave me love. I also want to acknowledge anyone who may be inspired by the artwork and by the text of this book from the beginning to the end.

This book is a collection of inspirations and visions that came to me during or after reading weekly parsha and Shabbat prayers throughout the years. The ideas were not chronological but, in this book, I begin with Bereshit. Some of these works came to my mind as a small vision which I developed into greater work of art with details and connections to other parashim. In regard to some parashim, I had different versions and in some, I have a painting from a scientific point of view. For example, 'Let There Be Light' as of the creation of the world, the way it described in the Torah (old testament) is so different than a scientific point of view. The ideas on some of the paintings came from things that happened in the 20th century or more recent tragedies in the world such as Holocaust and 9/11 twin towers terrorist attack.

Biography

I started landscape painting in Iran at the age of 17. While at college, I enrolled in painting courses and developed my style into abstract and geometric designs. Later I refined my painting style into a combination of symbolic, surrealism, and mystical with a Judaic biblical point of view.

I am also fascinated with landscape painting of American artists during 1800s, especially works of artists from 'The Hudson School of Art.' I reproduced paintings from masters such as Thomas Cole, Robert S. Duneken, Francis E. Church, and Albert Bierstadt. Within the last ten years, I am inspired by the work of an American artist, 'Shim Shimmel' who has a surrealistic environmental style and I try to follow his style in some of my recent paintings.

I had exhibitions in Long Island University (C.W. Post Campus), Art League of Long Island and a solo exhibition in Great Neck library. I usually use bright lively colors. Each one of my paintings has some deeper meaning than just the beauty on the surface. There is loneliness, hope, and a sense of awe. Some of my non-Judaic works subject matter are about American history and global warming. I believe we human beings are careless about the preservation of life, plants, and animals, and we should work more toward conservation than short term profit for the sake of our grandchildren and their grandchildren.

Bereshit

There have been countless paintings and murals by different painters regarding the creation, especially the creation of Adam and Eve, and their expulsion from the garden of Eden after the original sin. One of the most famous painting on the creation of Adam is by Michelangelo on the ceiling of the Sistine chapel. In this painting, God shows that He created man in His own image, also the pointed finger is that both man and God need to connect with each other.

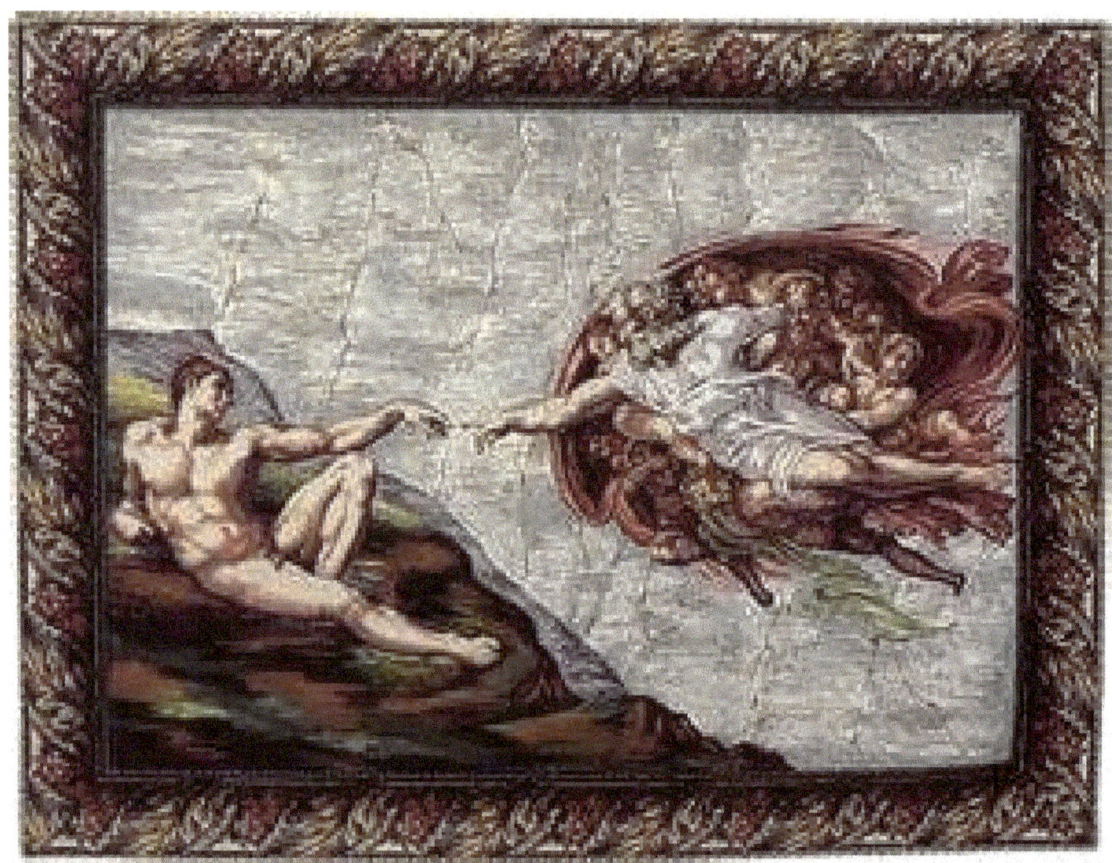

Figure # 01

Other cultures such as American Indians and their story of creation shows Mother Earth. She is also called Sky Woman; standing on a turtle and swimming in the endless sea that came after the great flood while blessing comes from above, and promise of a good life in harmony with nature is evident in the form of a rainbow. This myth belongs to Iroquois Indians. A few other tribes have different myths of creation.

In the Chinese story of creation, forces of nature are shown as dragon, unicorn, firebird, and we see the turtle again similar to Indian belief. In the painting below, there is the first man or Buddha looking toward heaven, and in the center is yin and yang which is a symbol of harmony and equilibrium between heaven and the earth.

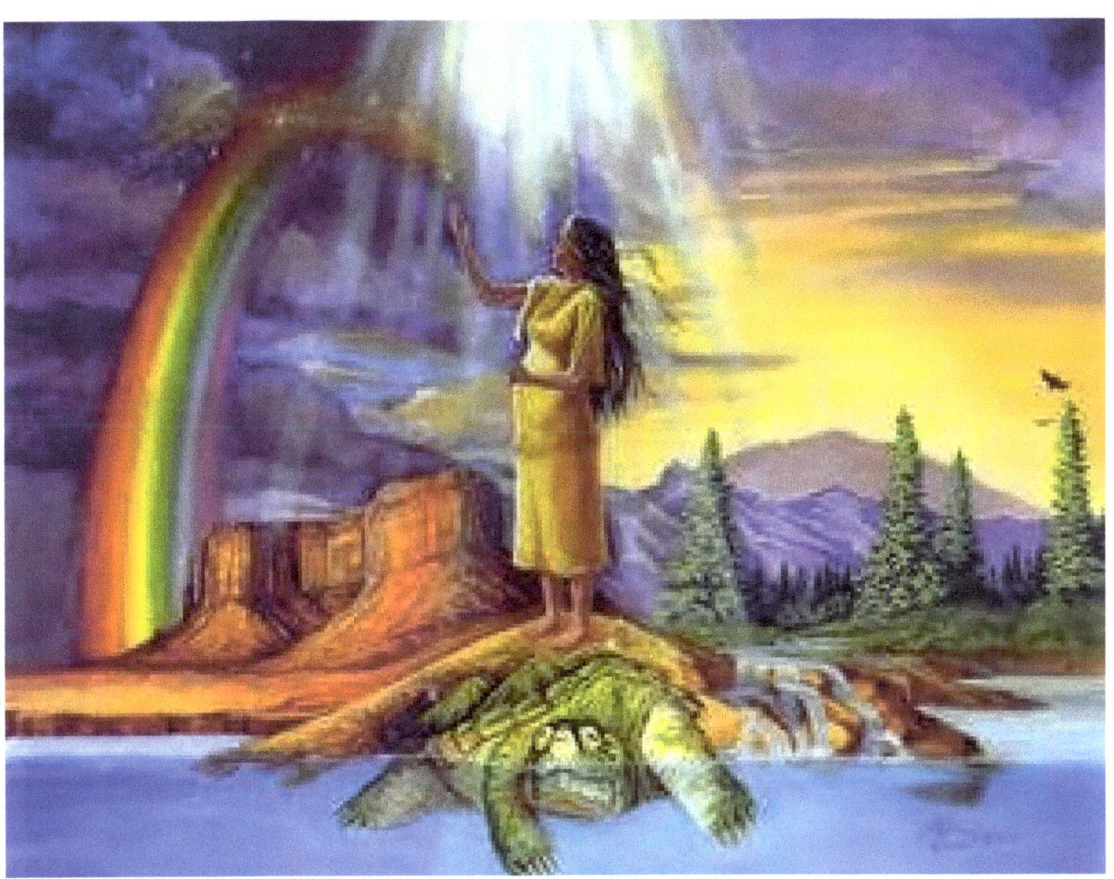

Figure # 02 This work taken from mystical American Indian Art

Figure # 03 This Work is from Chinese Mystical Art

I painted four different views on creation. One is totally according to scientific theories. The second one is a mix view of both science and bible. The third and fourth ones are taken mostly from the Old Testament. Since I painted them in a surreal, geometric, and symbolic style, there is some description needed that accompanies each painting.

According to science, at the very start of the universe, atoms and electrons were not organized. Then they unified and organized to form the galaxies, stars, planets, and life on earth and on other planets.

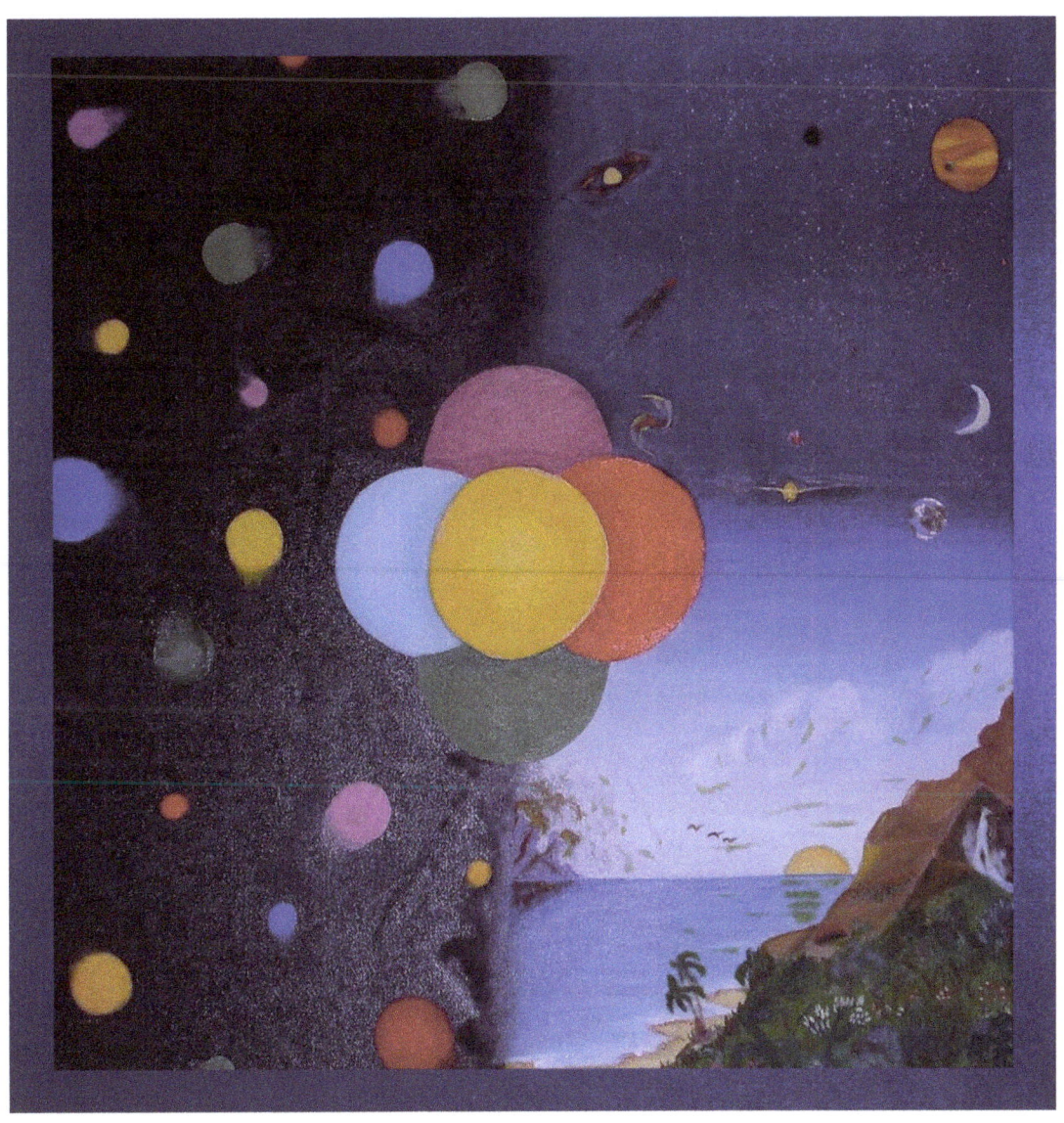

Figure # 04 1-In the Beginning 20x20

God created the world in seven days. Some argue that maybe each day took millions of years and the creation still continues up to the present time. The first day the square in the center of the painting is according to the big bang theory that started creation of the universe. Then galaxies formed stars and planets developed, and primitive life on earth began. Another day vegetable and fruit trees started to grow., Creatures of the sea evolved to be able to live on dry land. Then man was created. Day by day, generation after generation, man became more civilized and grew in knowledge and technology.

In the beginning, God created the heavens and the earth. When the earth was astonishingly empty with darkness upon the surface of the deep, the Divine Presence hovered upon the surface of the waters and God said, "Let there be light."

And God separated between the light and the darkness.

God said, "Let there be a firmament in the midst of the waters, and let it separate between the waters which were beneath the firmament and the waters which were above the firmament."

God said, "Let the waters beneath the heaven be gathered into one area, and let the dry land appear."

God said, "Let the earth sprout vegetation: herbage yielding seed after its kind and fruit trees yielding fruit." And there was evening and there was morning the third day.

God said, "Let there be luminaries in the firmament of heaven to separate between the day and the night, and they shall serve as signs, and for festivals, and for days and years, and they shall be as luminaries in the firmament of heavens to shine upon the earth." And there was evening and there was morning the fourth day.

According to commentaries, light and darkness were two separate entities that were created, and light had an intense spiritual quality. Light, in my opinion, symbolizes wisdom and knowledge, and darkness is lack of knowledge and understanding. The Torah also describes the heavens as a plural body but the earth as a singular. This indicates that there are different levels of heaven corresponding to levels of spirituality.

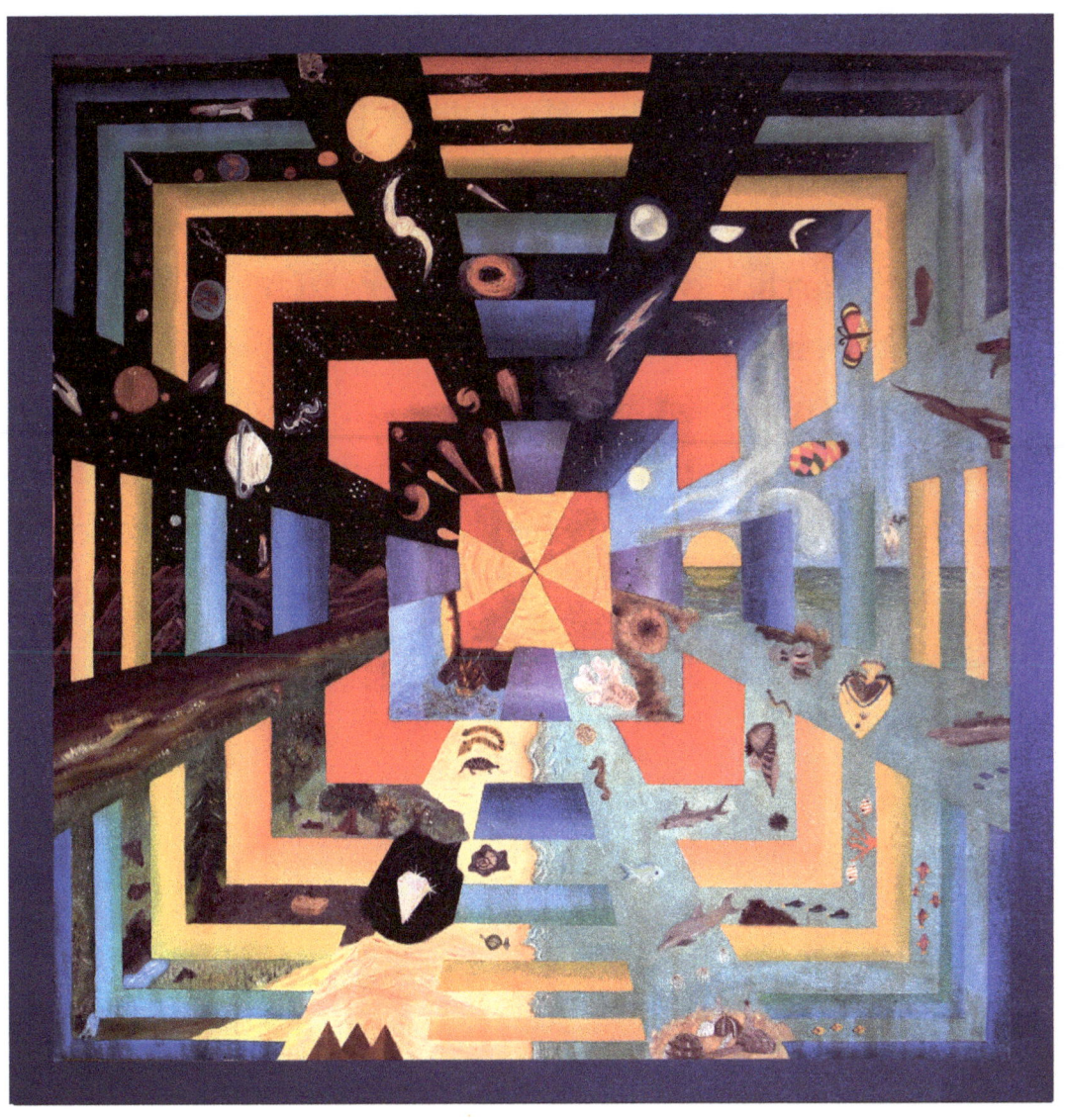

Figure # 05 2-Seven Days of Creation 30x30

Day two of the creation is not elaborated and is full of mysteries that is not understandable by the physical ordinary man. The firmament separates between the wholly spiritual aspect of creation and the tangible world that we exist upon. Up to the third day, the earth was submerged underwater. In order to put a limit and boundary to everything on the earth, God gathered waters in one place and dryland in another. On the third day plants started to grow on land, although there was no sun in the sky to give them energy and in my opinion, God's spirit and energy has to be in seeds and plants in order for them to grow, yield flowers, fruits, and seeds. And then on the fourth day, the sun and the moon were set in place, they were created on the first day but God assigned their position on this day.

In this painting I have shown day one to day four of creation. At day one earth and sky were mixed in each other, and that's why I show a part of the earth below and another part above. I symbolized creation of light to wisdom of creating life that is inscribed in DNA double helix molecules. Firmaments that separate waters are symbolized as cups. At the beginning, life started in water as is seen as lotus flowers. Since there was no sun yet, trees are shown in a dark silhouette. At day four sun and stars are put in place in the sky.

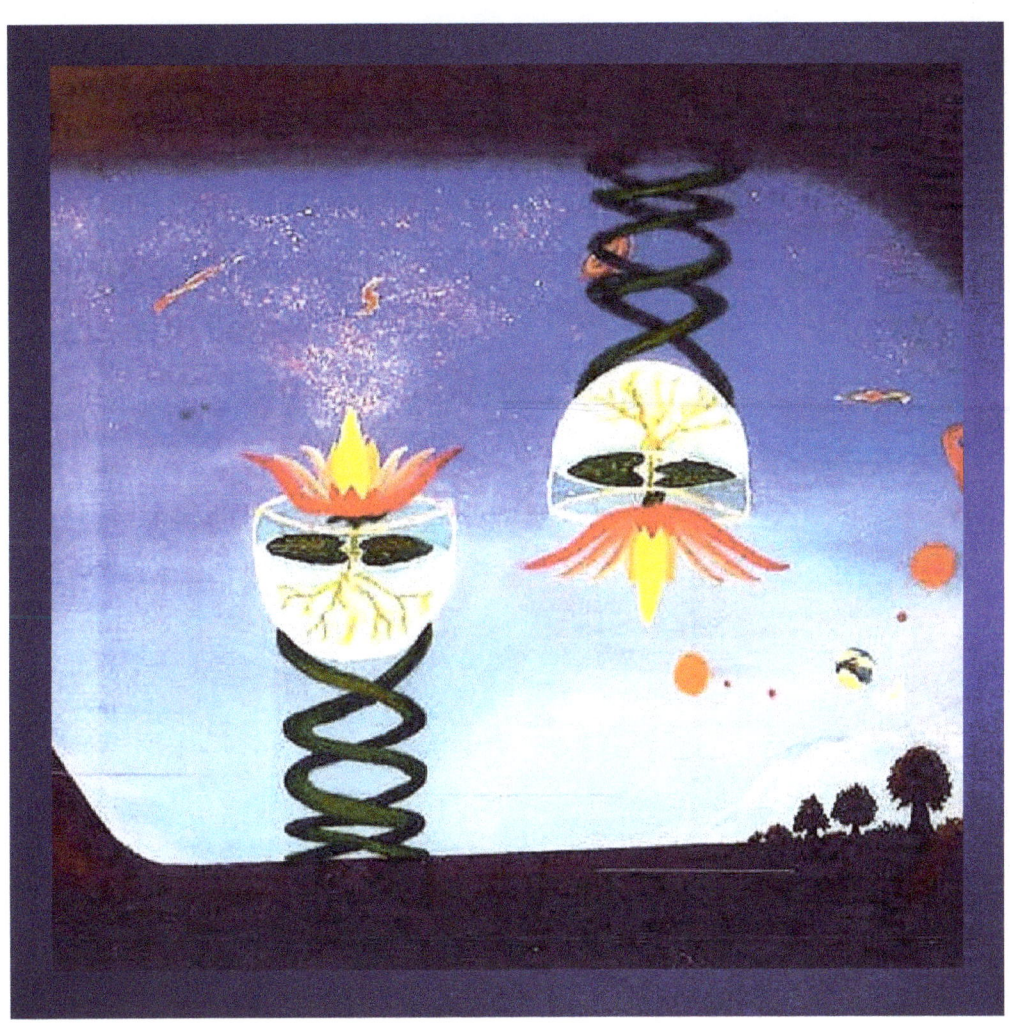

Figure # 06 3-Let There be Light 20x20

This painting is done at the beginning of 2017 before Passover Holiday. It is a combination of scientific theory of creation and the Old Testament way. At the bottom it is all black, nothingness. Then God created a cluster of stars and in between these God created the atoms. Here, I painted hydrogen, oxygen in the form of O2, carbon, nitrogen, phosphorus, and sulphur, which are most abundant in organic molecules that have to do with life as we know it on earth. The molecules on the left side are; glucose, lipid and protein.

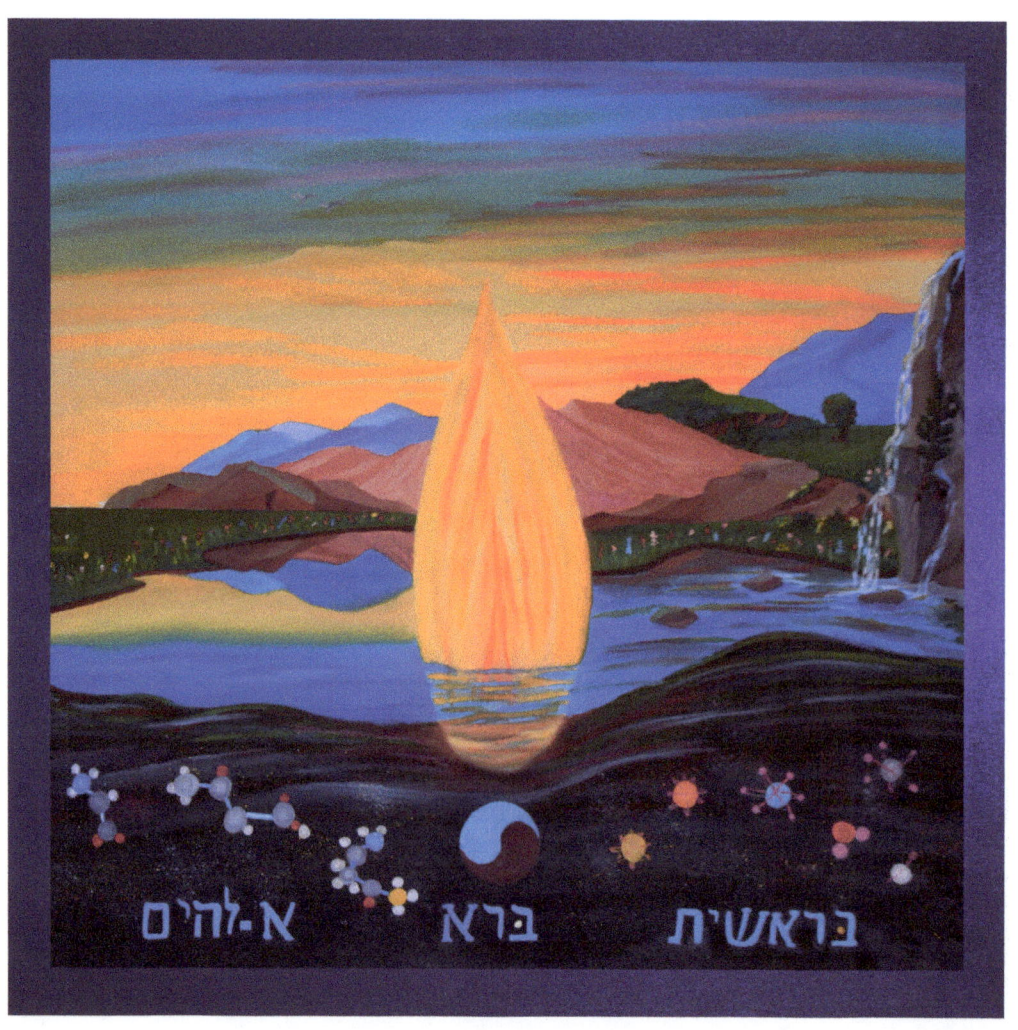

Figure # 07 4-Bereshit 30x30

The yin and yang symbolize balance and equilibrium. I painted it blue and brown, representing heaven and earth. The candle represents light, wisdom, and unity. In the Bible we read that heaven and earth were all mixed up together until God separated them, and gave them borders and laws to act on each other. That's how I painted the bottom of the candle water in the middle of the fire mixed with earth. On earth and life, in particular, there are times of rush and change, the same as a waterfall and river that changes the surface of earth and times of tranquility as a peaceful lake. Timeline of the painting is sunrise of day six of the creation.

The Original Sin

There are not that many works of art on the subject of Adam and Eve eating from the tree of knowledge which is known as 'The Original Sin.' But there are many works on expulsion of Adam and Eve from heaven.

This work is by Michelangelo on the ceiling of the Sistine chapel.

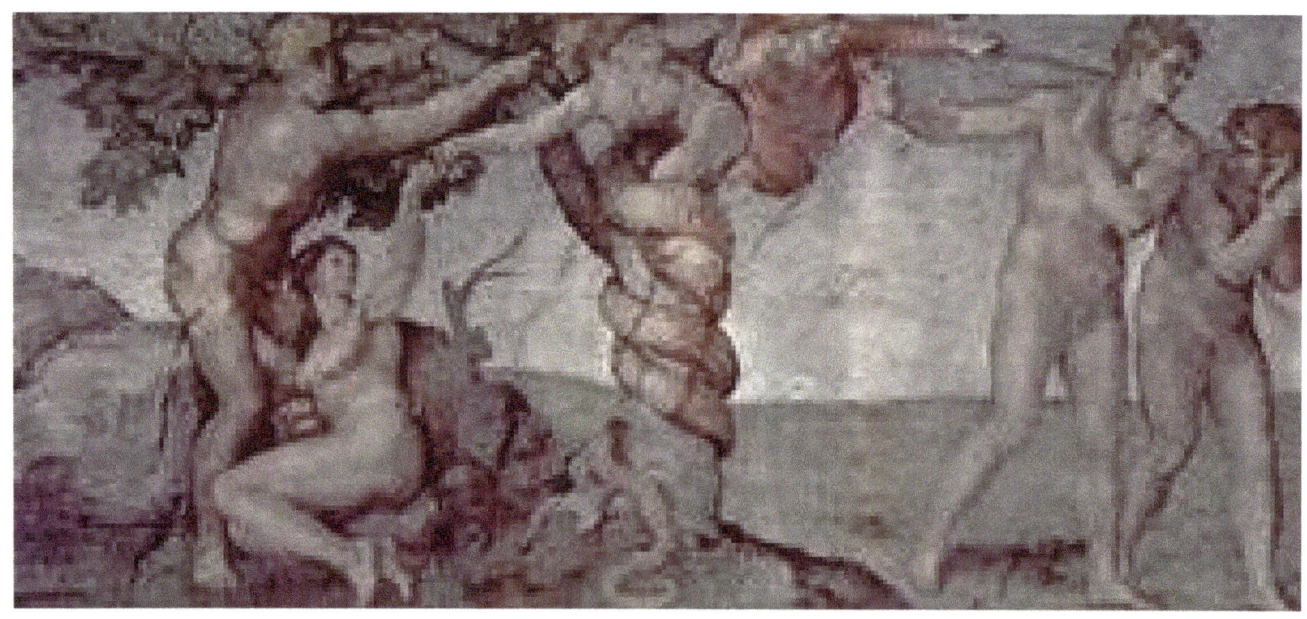

Figure # 08

This painting is by an American artist, Benjamin West, who lived from 1738 – 1820. He was a historical and a religious painter.

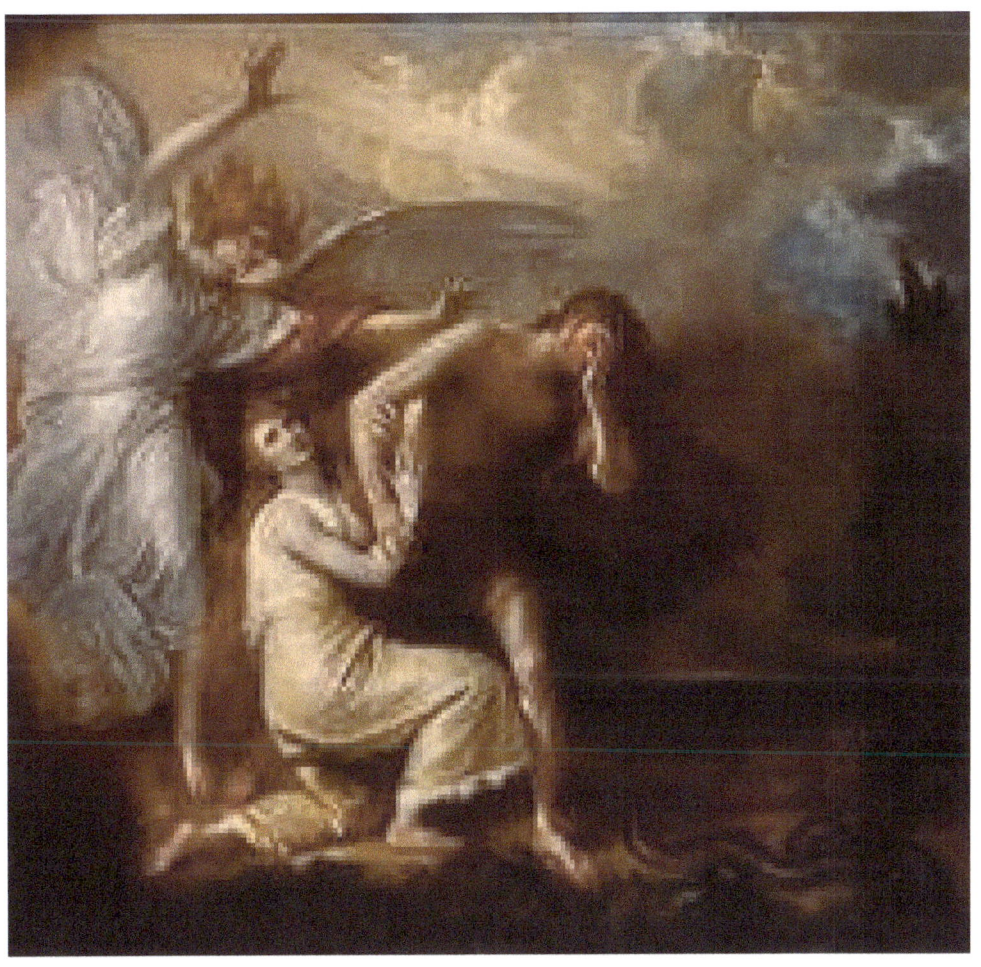

Figure # 09

In this painting, my version of the original sin I am comparing is the garden of Eden to earth. Adam and Eve are already on earth looking toward the garden of Eden. The apple is eaten by both of them by the door, reminding them of the comfort they have lost. All the fruit they could eat without effort, clean water, pleasant scenery, and warm, comfortable temperature, and the spirit of God above them.

Here on earth, there are forces of nature, hot sun, clouds, and cold wind. They have to work for their bread and wine and there are gravels under their feet. The door to heaven is half-open, symbolizing there is a way to go back to Eden through stepping up toward spirituality.

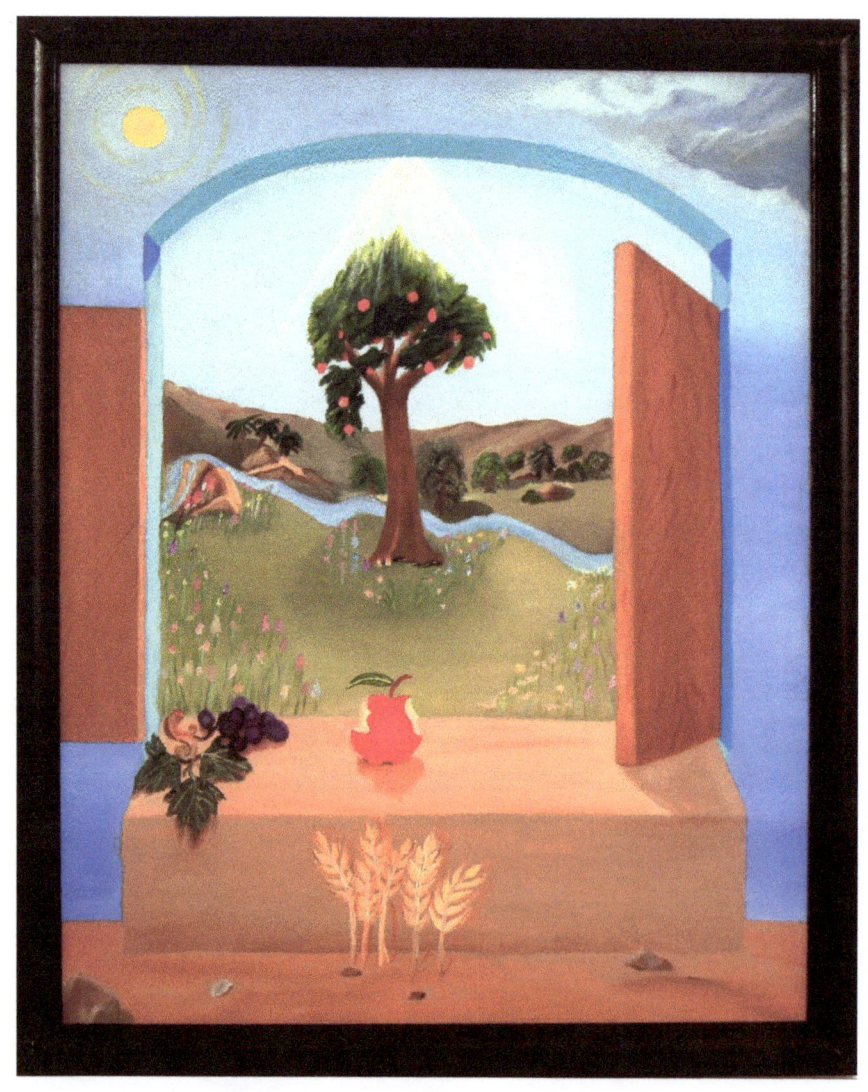

Figure # 10 5-The Original Sin

Noach

There are so many paintings and drawings from Noah's Ark. Most of the paintings are from the earlier construction of the Ark and the time that animals were gathered to go into the ark. Very few show the Ark during the storm and of course, some paintings are of the time when the Ark was settled between the mountains and all creatures were coming out.

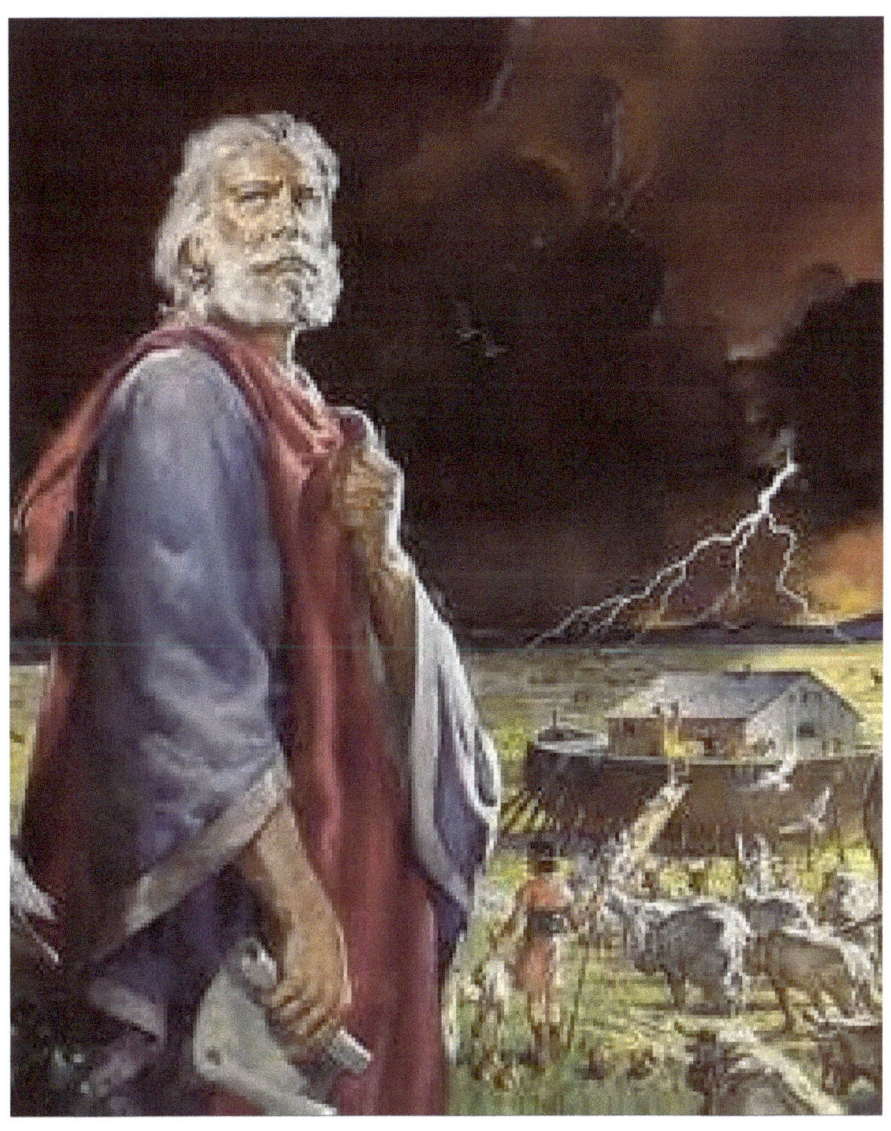

Figure # 11 These Painting are from Story Book About Noah

Lots of drawings are in the children's book. There is also an animation movie made by Disney Studio for a classical music called 'Pomp and Circumstance Marches,' composed by Sir Edward Elgar on 1901. In United State, this march is played on college graduation ceremonies.

There is also a comedy movie called "Evan Almighty," about a modern-day Noah trying to save the animals from public land bill that gives developers and mining companies the power to do whatever they want without public concessions on public lands.

There are discussions on the shape of the ark as most painting show the ark as a big ship narrowed at both ends. Another group of scholars say that it was rectangular. Below are some of the more interesting and artistic paintings that I found in animation and surrealism.

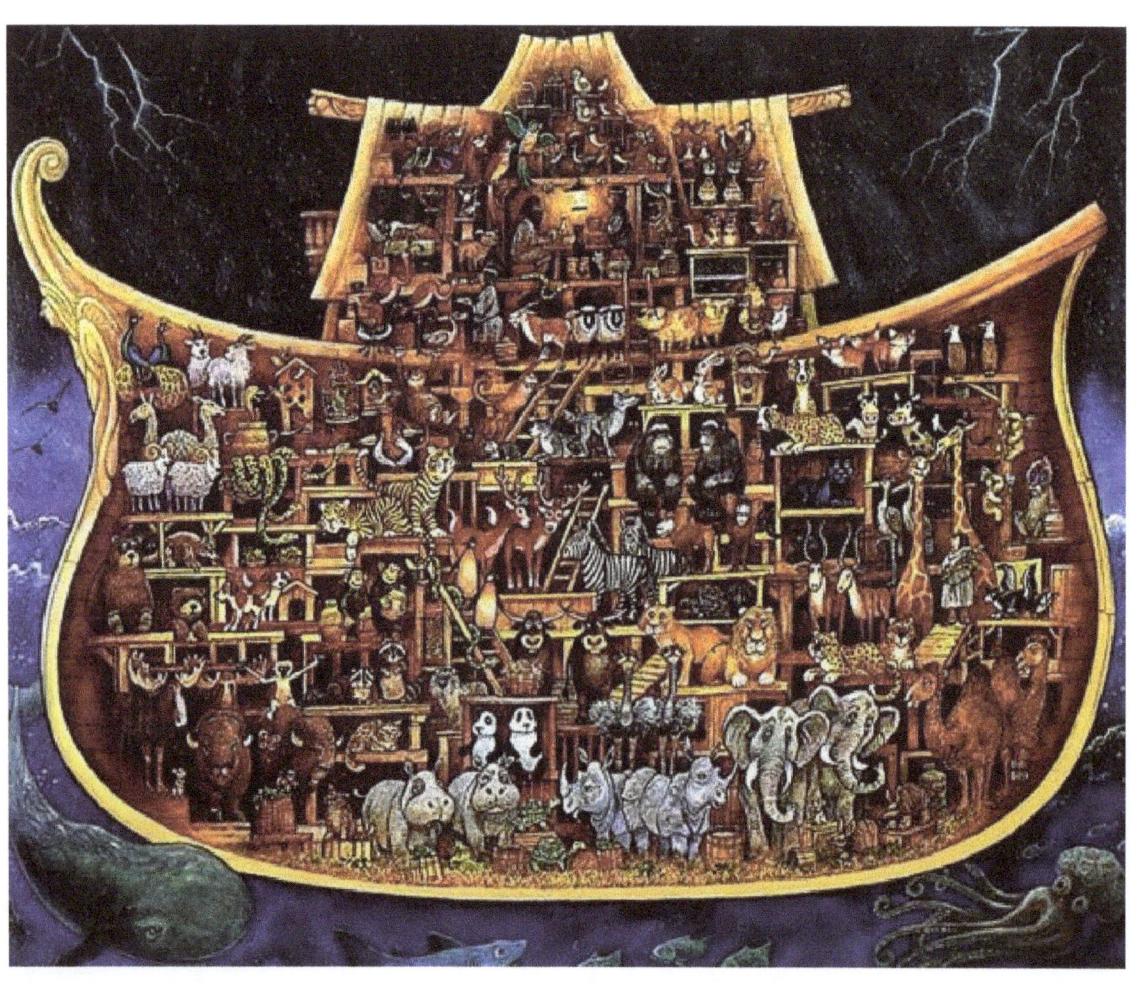

Figure # 12

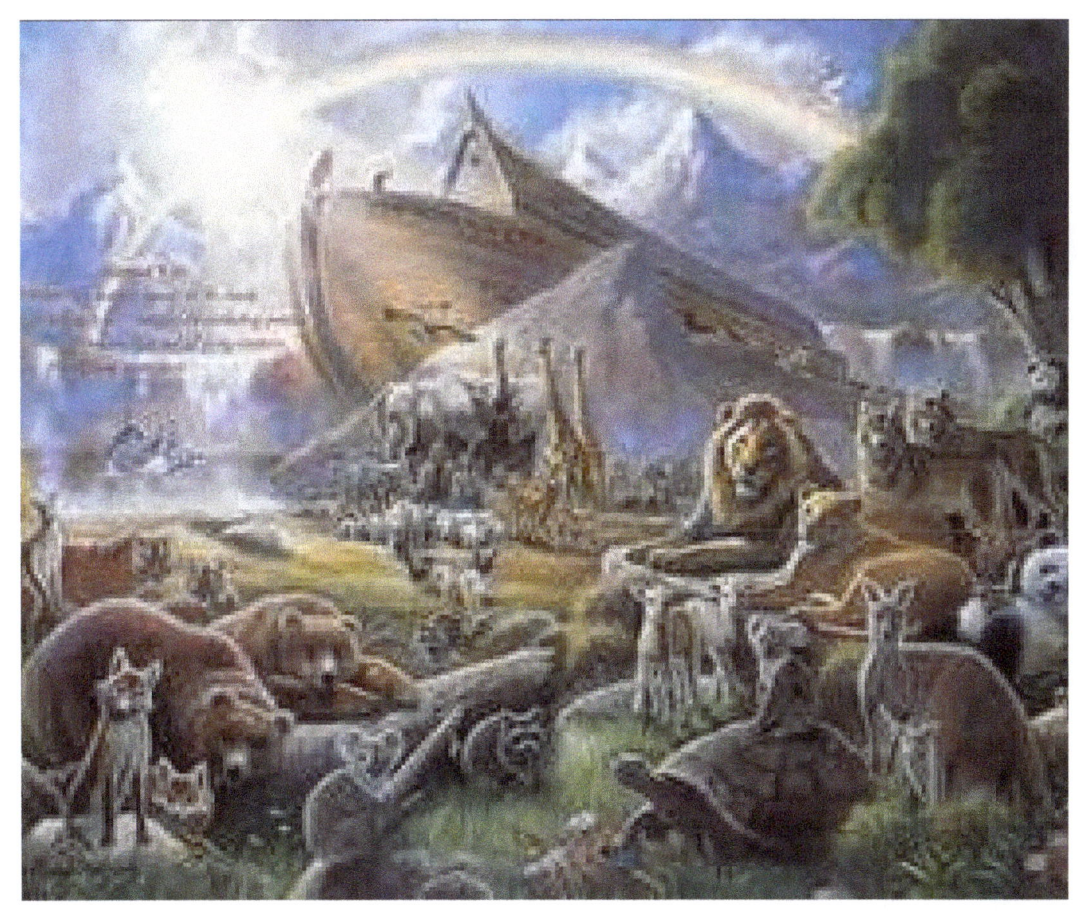

Figure # 13

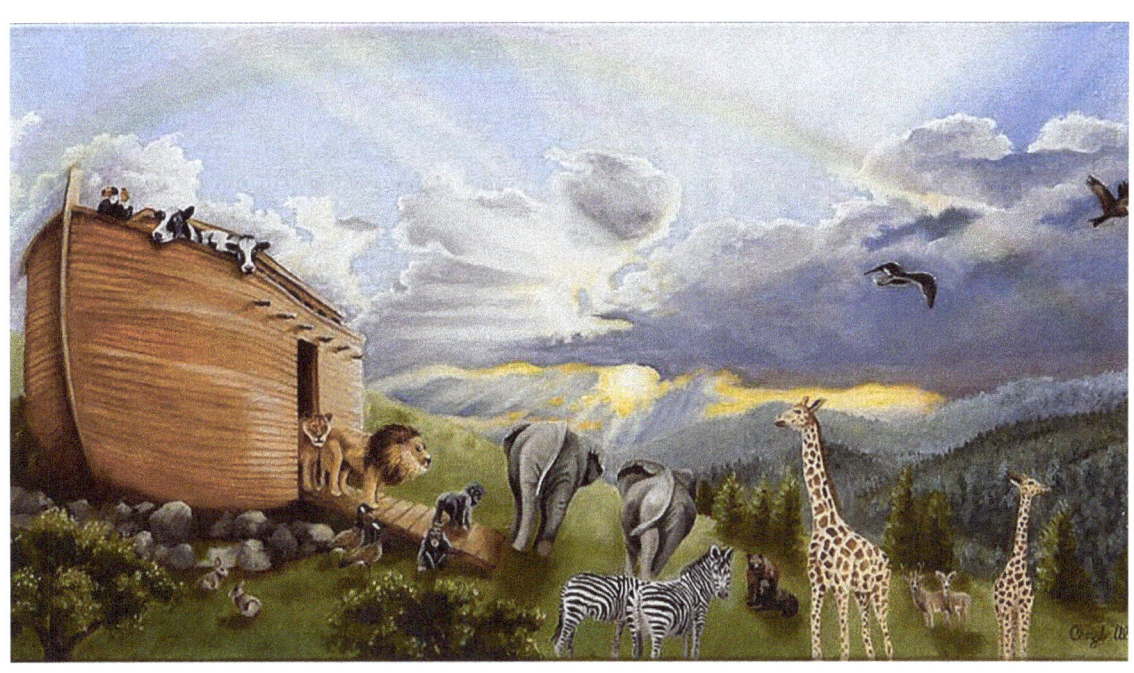

Figure # 14

God said to Noah, "Make for yourself an Ark of gopher wood with compartments, and cover it with pitch inside and out. Behold, I am about to bring the flood waters. You shall enter The Ark with you wife, your sons, and their wives. And from all that lives two of each, you shall bring a male and a female. And gather every kind of food for yourself and for them."

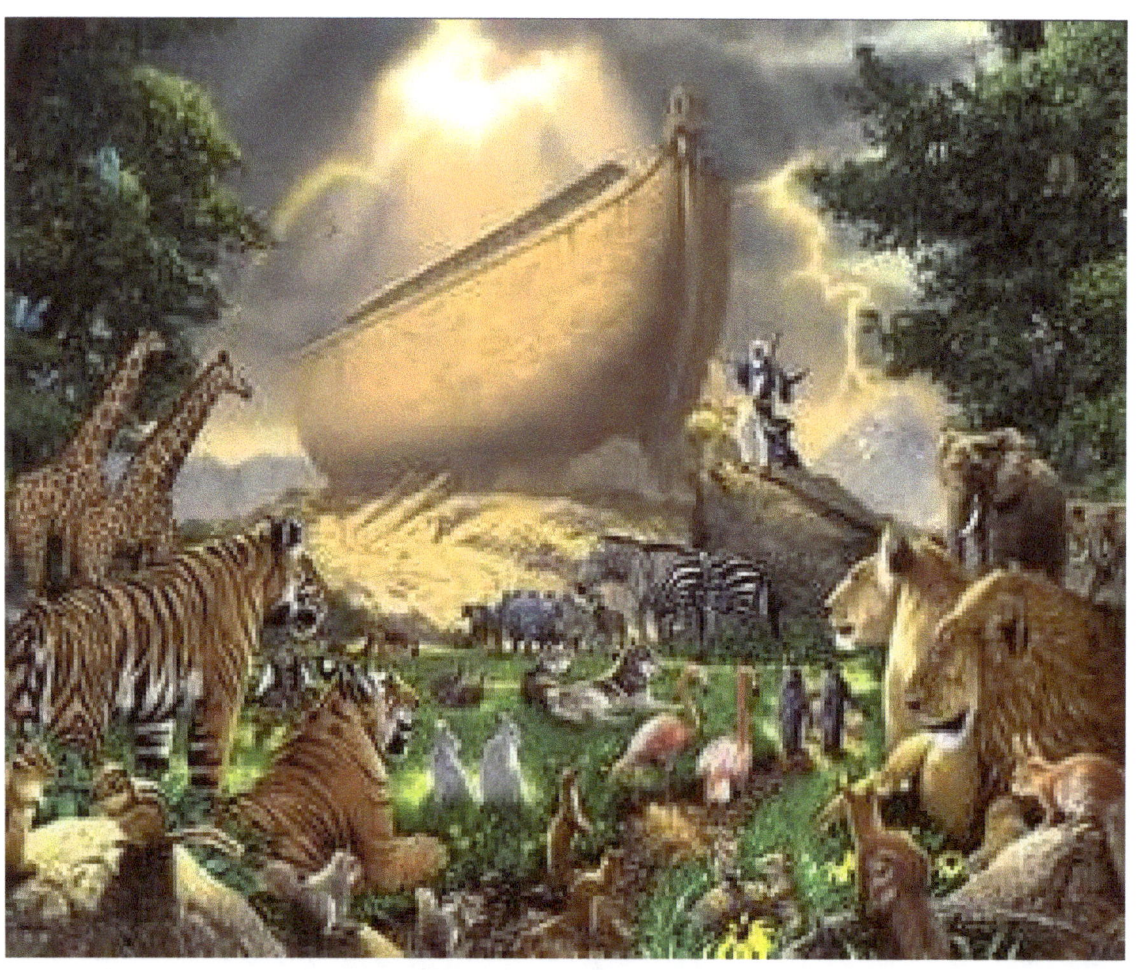

Figure # 15

God said to Noah, "I will establish my covenant with you and your offspring. I have set my rainbow in the cloud and it will be a sign of covenant between me and the earth."

Noah debased himself and planted a vineyard. He drank of the wine and became drunk, and he uncovered himself. Ham saw his nakedness and told his brothers. Shem and Japheth took a garment and walked backwards, and they covered their father. There is a painting by Michelangelo on this episode.

I produced three paintings about Noah's Ark. One is at the time after the forty days that the rain has stopped and clouds are clearing away. The other one is when the waters are receding and top of the mountains are visible. The third one is when the dove comes back with the olive branch on its beak.

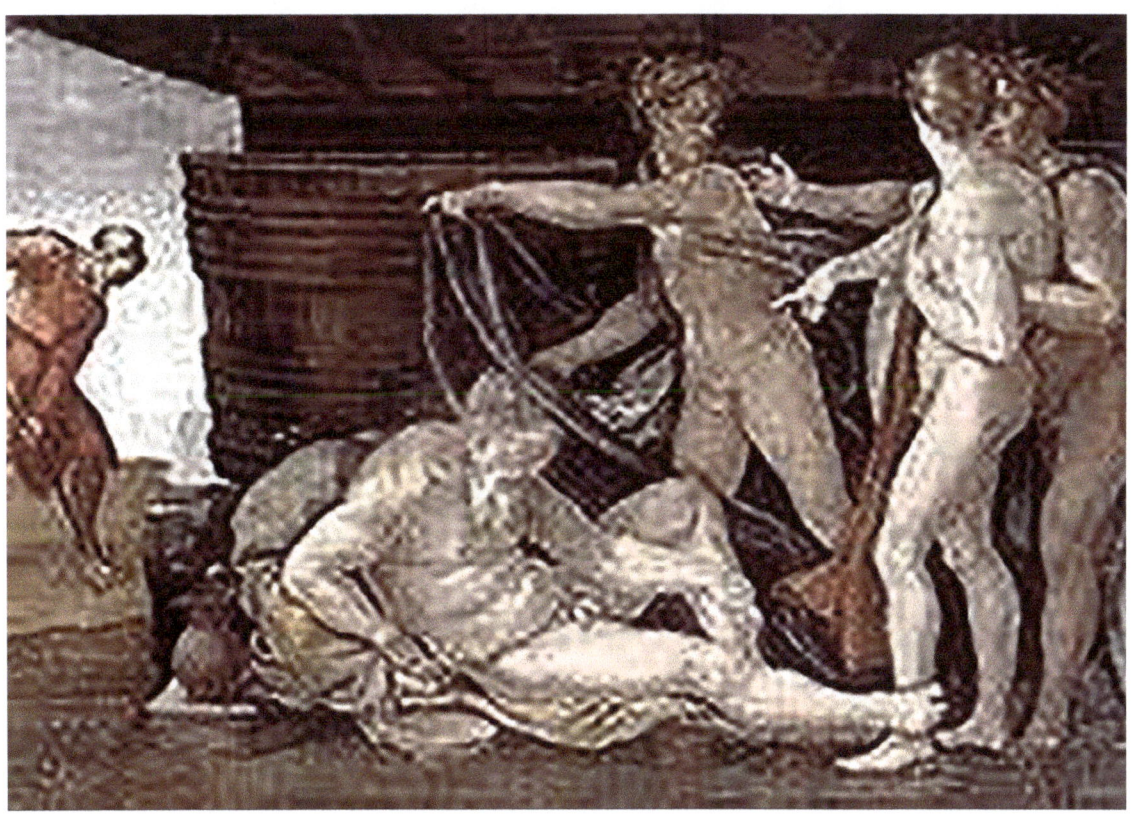

Figure # 16

In his painting after the forty days of rain, clouds are clearing up and the sun is shining. The Ark and everything around it is protected by a rainbow color grid, symbolizing the hand of God.

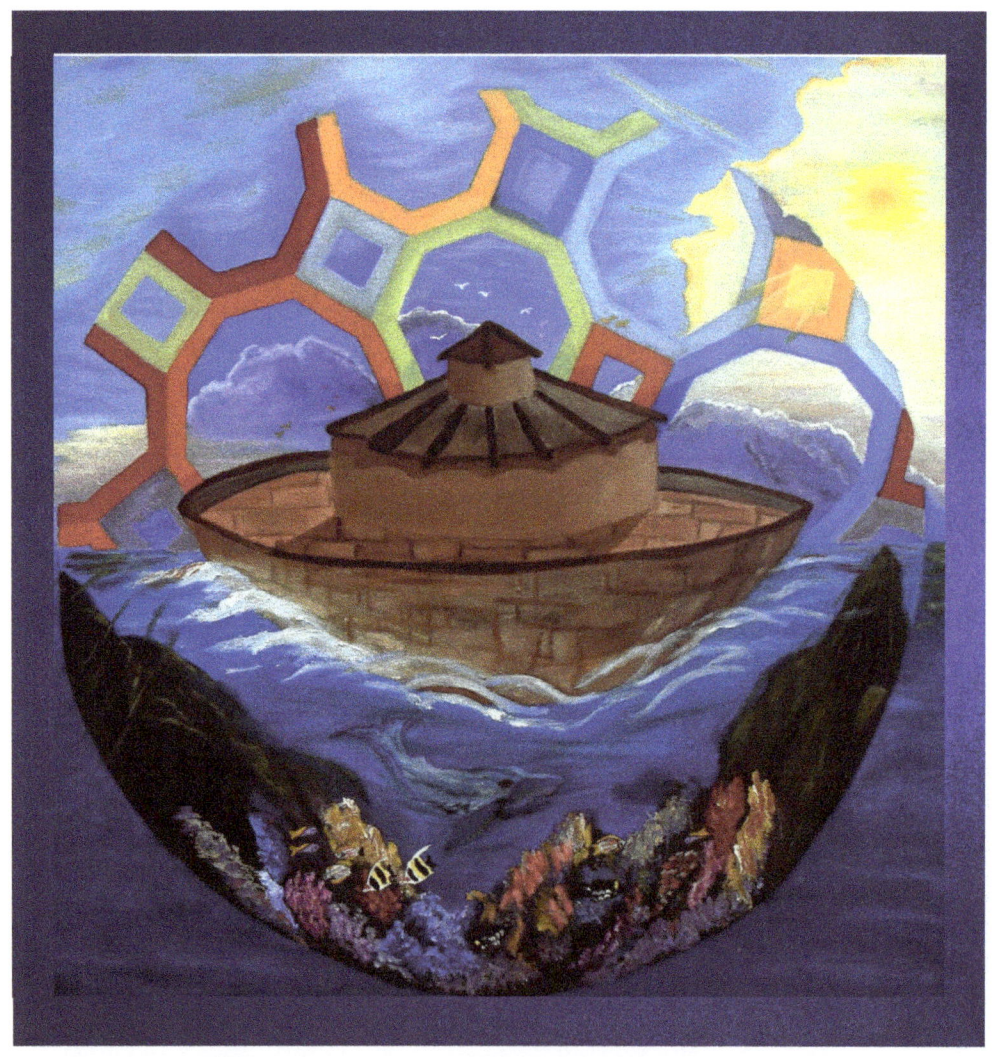

Figure # 17 6-End of the Deluge #1 20x20

In this painting as the Ark comes to land, there is a rainbow symbolizing a bright future for mankind. The glass of wine, turtle, and the olive branch symbolizes sweet, long, and rich life. The cloud looks like a man's face looking up toward heaven for God's blessing.

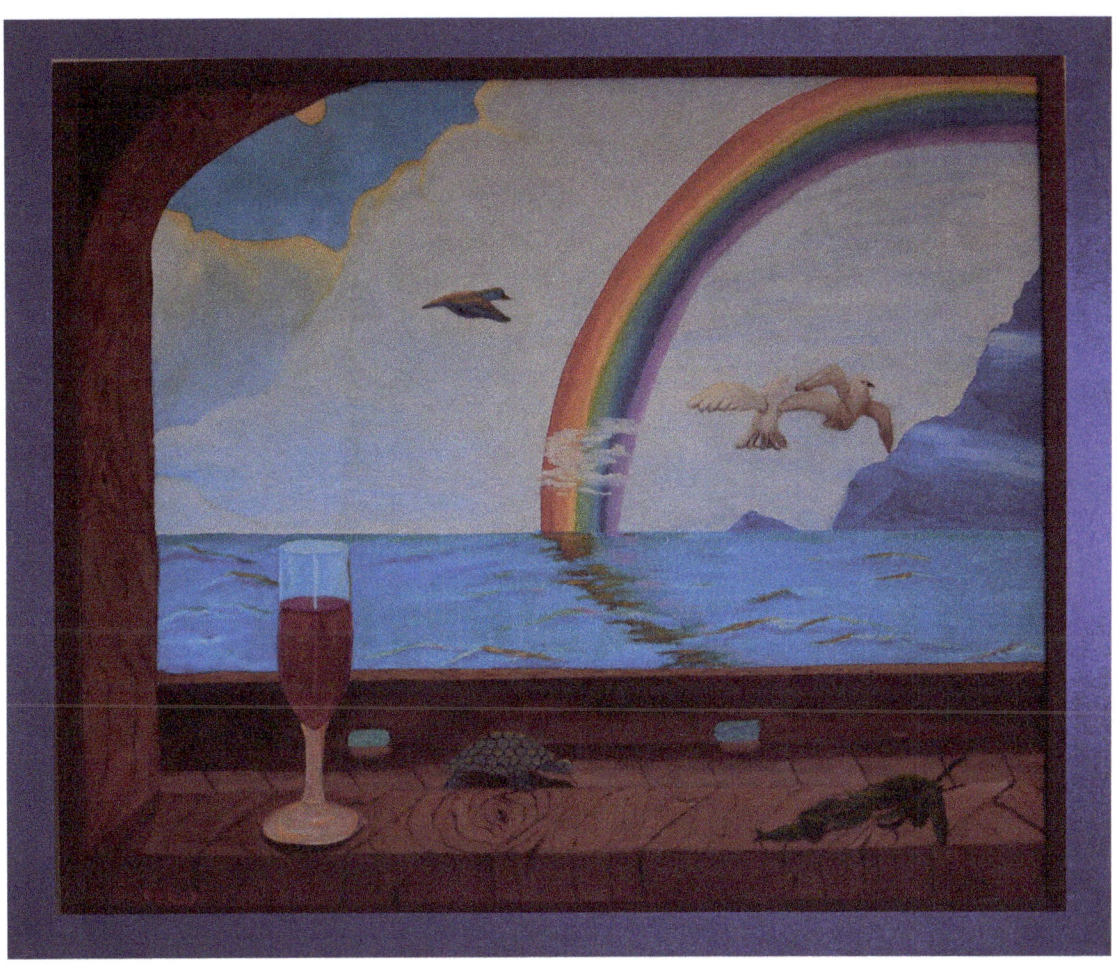

Figure # 18 7-Looking out from the Inside

As the waters are receding and the ark is coming to land, there is promise of peace in the rainbow and animals are joyful that they will be free from the Ark. The dove is returning with an olive branch in its beak representing peace. God's light is shining from the left-side, keeping the universe in harmony.

340 years after the flood, Noah and his children were still alive, and Abraham at 48-years-old has already recognized his Creator. Around that year, Nimrod subjugated the Babylonians and incited them to rebel against God. Up to that time before Nimrod, there were no wars and no monarchs. Everyone lived in peace, unity and they all spoke in one language.

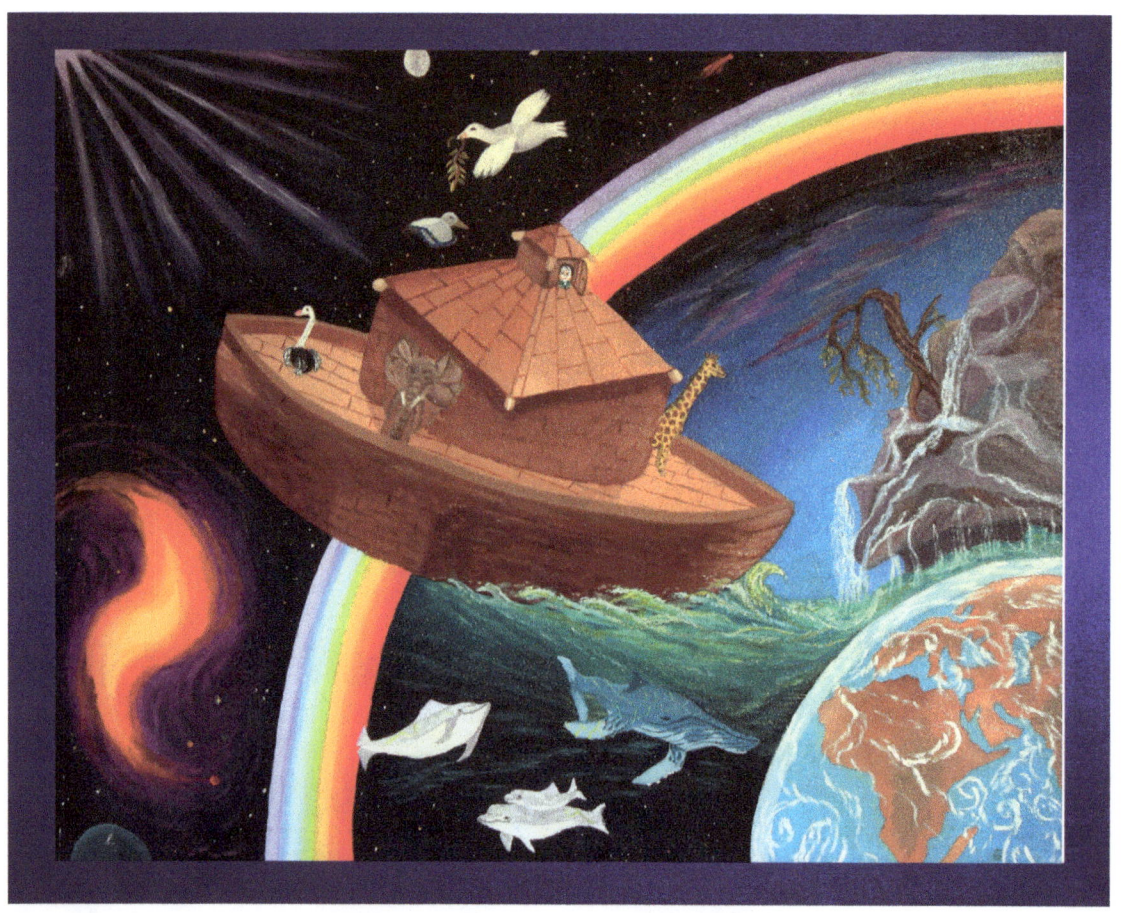

Figure # 19 8-End of the Deluge

"The whole earth was of one language and one purpose. They said to one another, Let us make bricks and burn them in fire. And the brick served them as stone, and bitumen served them as mortar. And they said, let us make a city and a tower with its top in the heavens."

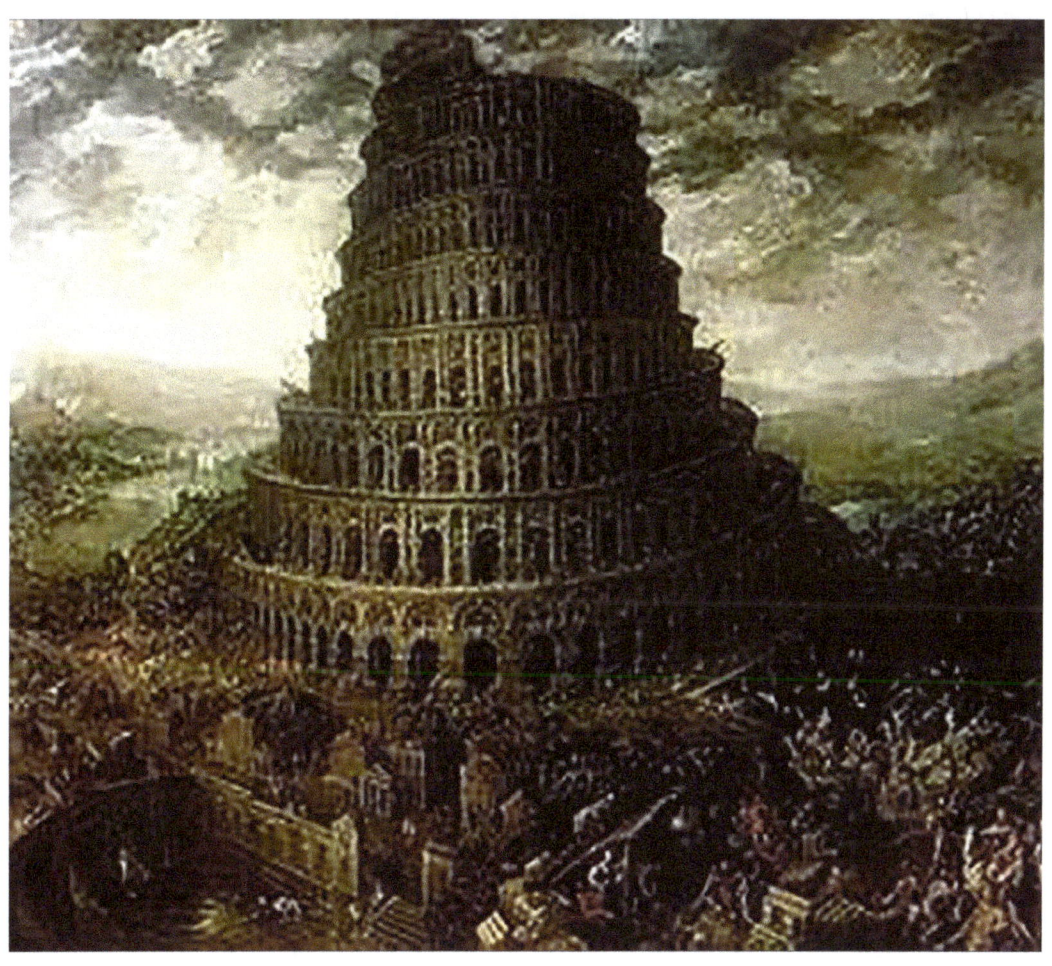

Figure # 20 8-End of the Deluge

God looked and saw that people are using their unity and creativeness to build a useless tower which will be waste of time and waste of life instead of building something useful to benefit and improve people's lives. So, he confused them and changed their languages to disrupt this. According to the sagas, Nimrod was the primary force behind this rebellion. He planned to build the tower and wage war against God. As for the memory of the flood which should have frighten them from confronting God, the builders of the tower rationalized that such an upheaval happens only once in 1656 years so they have nothing to fear from Divine intervention for another 1316 years, by that time they would have waged their war against God and won.

There were ten generations from Adam to Noah which failed in living morally so the flood came. There were also ten generations from Noah to Abraham, although these generations were also idolatrous and immoral but this time Abraham was able to save the world from destruction. Abraham and his offspring would be the people of God and bear the responsibility for bringing the Divine plan into fruition. The children of Noah would be left with seven universal commandments but Abraham would accept the Torah with its 613 commandments. There have been many paintings, drawings, and other types of artworks by different European artists, mostly around 1600 – 1700s. Most of these artworks are kind of similar in shape and design of the tower.

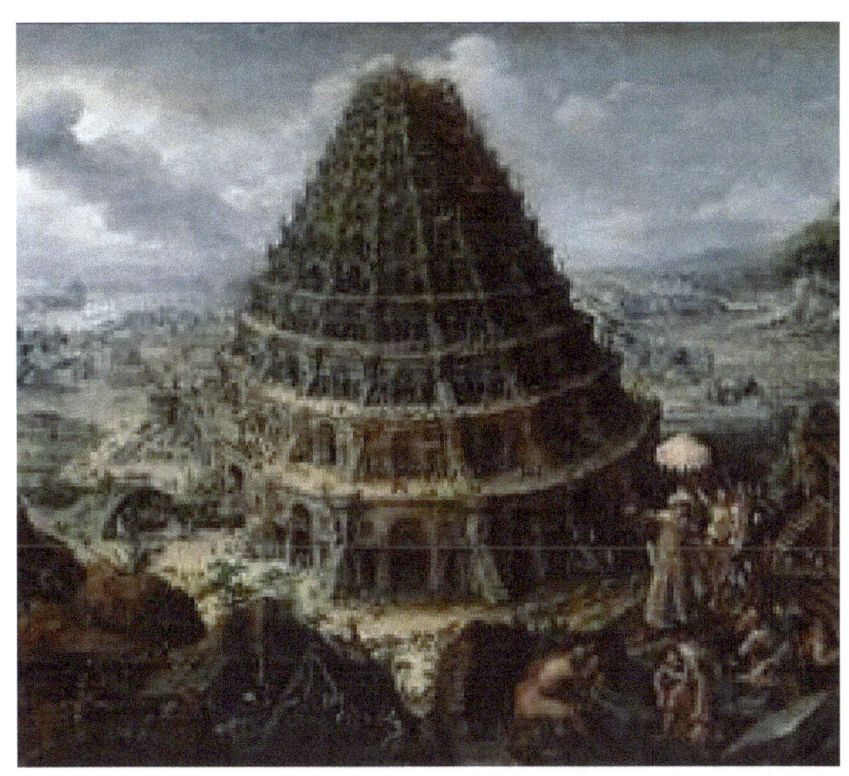

Figure # 21

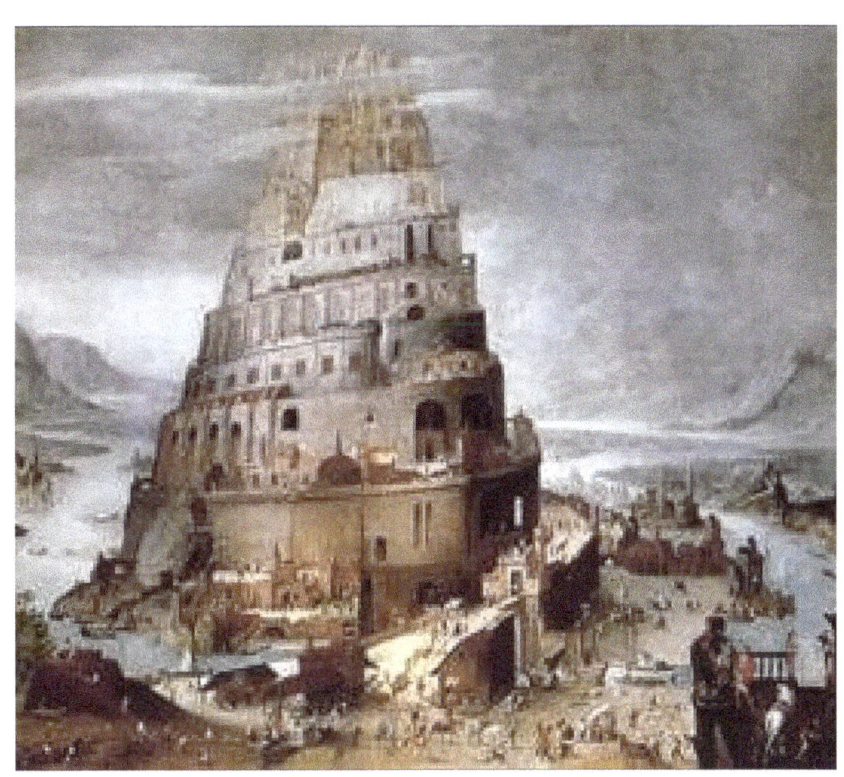

Figure # 22

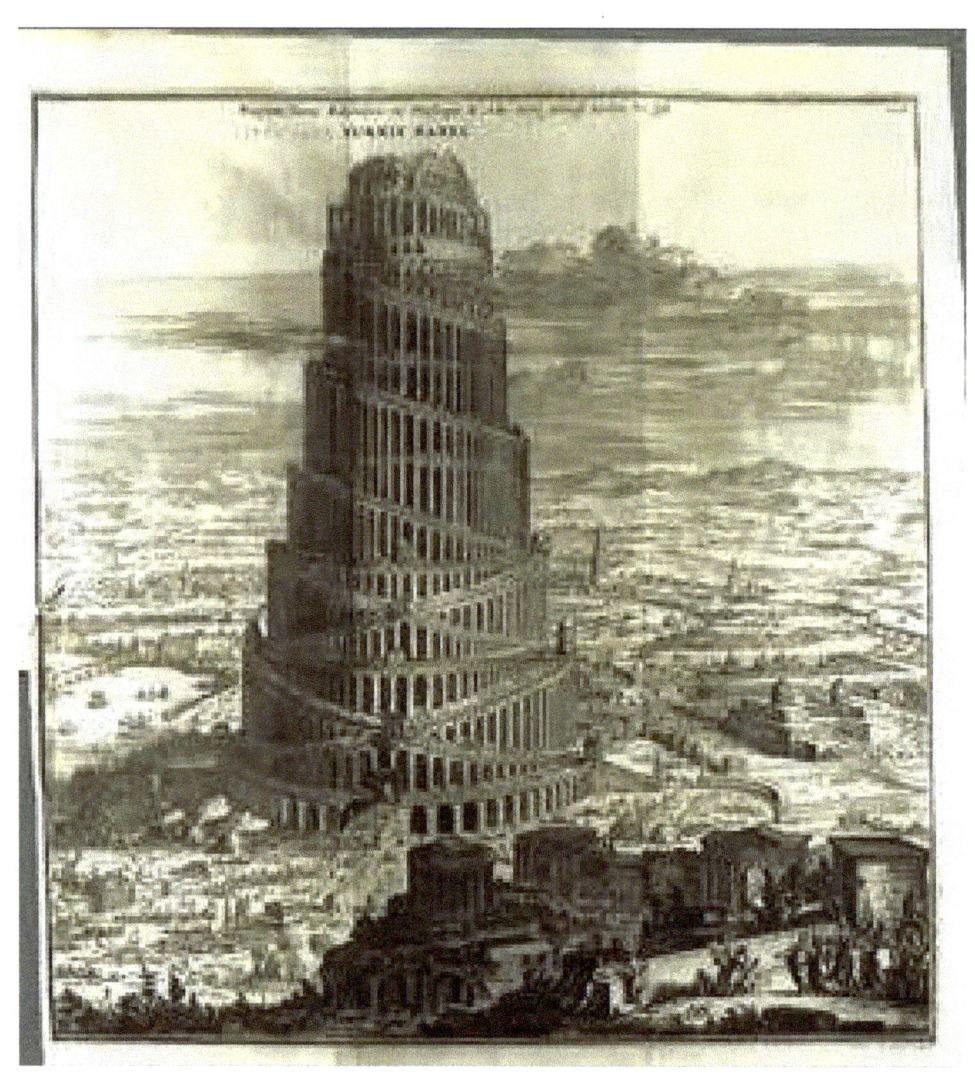

Figure # 23

This is a woodcut by M. C. Escher. He was a master of graphic design and print making. Escher was born on 1898 in Nederland. After finishing his studies in 1922, he traveled to Italy and Spain for many years to find subjects to draw, and develop his printmaking. After 1941, he returned to Netherland. From that time, he changed his style to drawings from his imagination. He died on 1972.

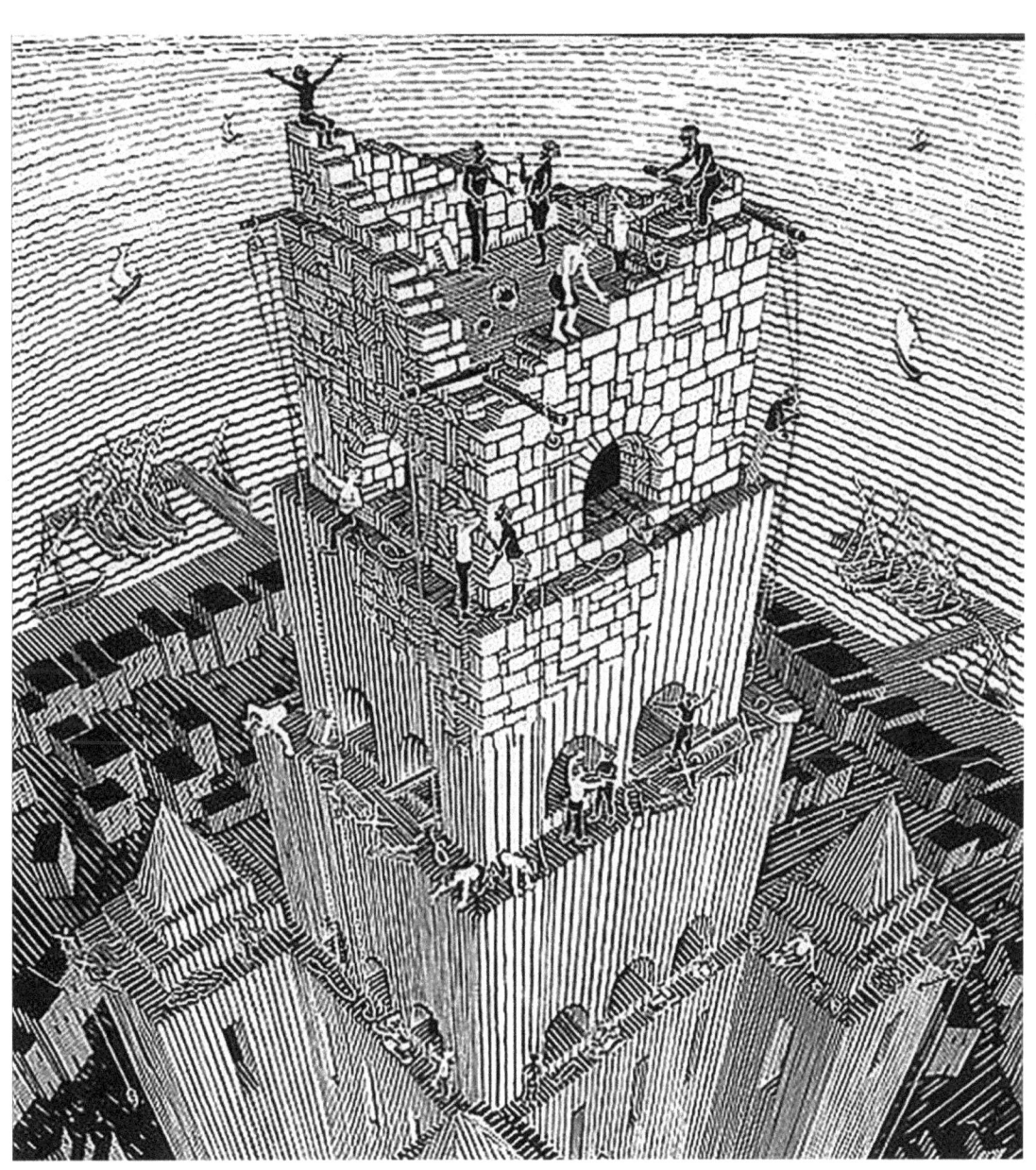

Figure # 24

It is so fascinating how the mind works; where the inspiration and visualization comes from and what triggers the mind to come up with that clear image. Sometimes you read a parasha, the translation and comments or sections of Siddur (daily prayer book) for the first time, and suddenly a clear picture comes to your mind. Other times some parshas you read, year after year, and you cannot visualize it to put it on a canvas.

Of course, this ability is different from one artist to another. It also depends on family background, education, and a timeline in history the artist is living in.

This visualization also depends on how much the artist reads on different subjects, the amount of travel, openness, and social status in the artist's lifetime. We should not dismiss the act of God and the purpose that the Almighty has given that talent to the individual artist. In the Parshat Ki Sisa for construction of Tabernacle and all the utensils, Hashem spoke to Moses saying, "I have called by name, Bezalel the son of Uri, of the tribe of Judah. I have filled him with a Godly spirit with wisdom, insight, and knowledge, and with every craft, to weave designs, to work with gold, silver and copper, stone cutting for settings, and wood carving to perform every craft."

During the centuries, artists and painters created very important periods or actions that happened in the bible, actions that changed the history of mankind. Such as expulsion of Adam and Eve from heaven, the flood, Tower of Babel, Abraham sending out Hagar and Ishmael that created generation of Arabs, and many more which I will include later in the book.

Sons of Noah that came out of the Ark became the forefathers of Hebrews, Greeks, and Canaanites.

During the construction of Babel Tower, different languages and seventy nations were developed.

Vayeira

In this parsha, there are three major events that are painted by Biblical Artists.

1 Destruction of Sodom and Gomorrah.
2 Abraham sends away Hagar and Ishmael into the wilderness.
3 Binding of Isaac at Mount Moriah.

Because of the unimaginable violence and destruction of Sodom and Gomorrah, this is the best painting that shows the angles accompany Lot and his daughters away from the city to the mountains while Lot's wife turns back to look and turns into a pillar of sand.

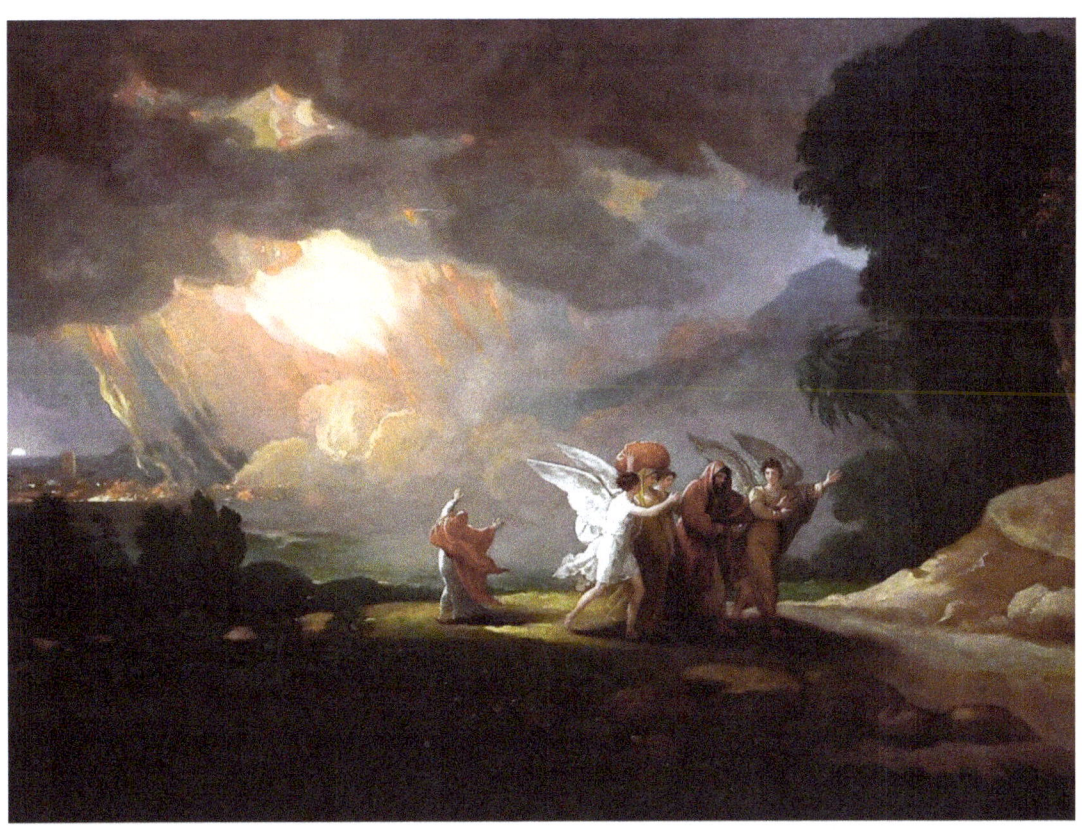

Figure # 25

This painting shows Hagar prays in the wilderness while Ishmael is fainted and God's Angel is on the way to save them. Then Hagar see water coming from a rock.

This rock is the same rock that accompanied Israelites in the desert and was the source of water for them for 40 years.

The rock stopped watering after the death of Miriam (Moses sister). People got angry because of lack of water. God said to Moses to pick up his staff and speak to the rock to start giving water, but Moses made a mistake in finding it by striking another rock twice instead of talking to the designated rock. So, the miracle did not happen the way it was supposed to happen in the eyes of people. Moses was punished by not setting foot on the land of Israel.

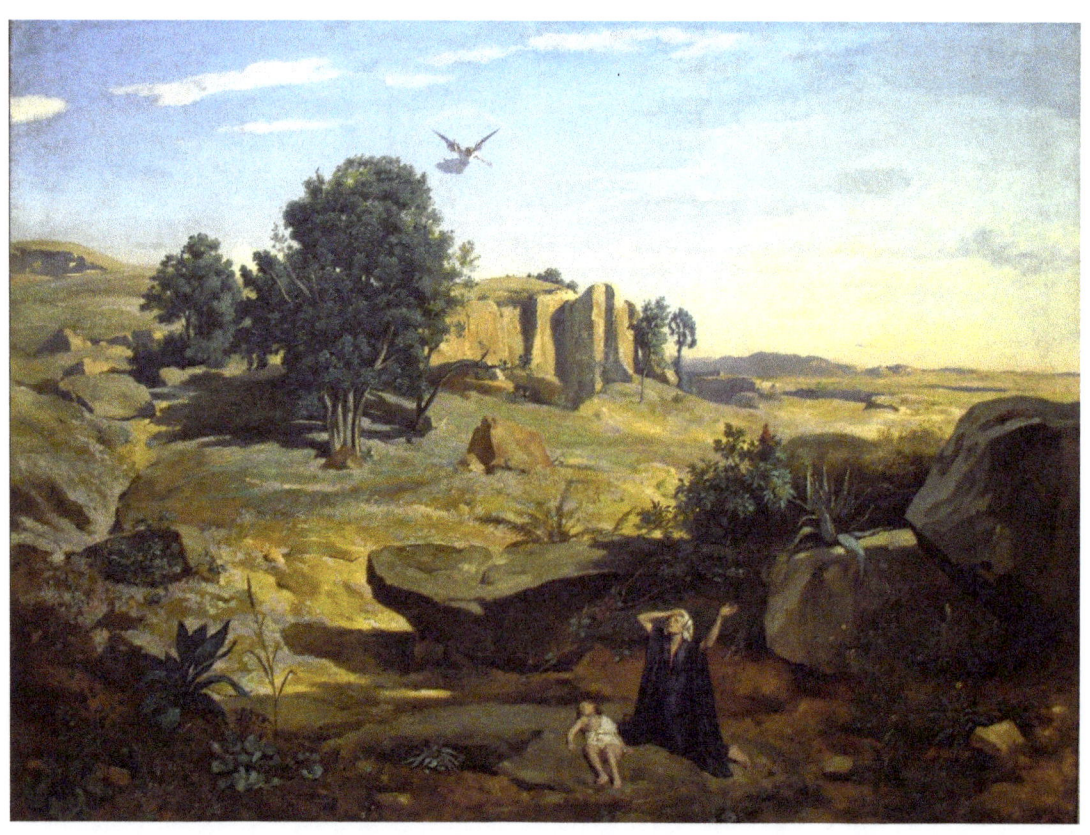

Figure # 26

And it happened after these things that God tested Abraham and said to him, "Abraham," and he replied, "Here I am."

And God said, "Please take your son, your only one, whom you love—Isaac—and go to the land of Moriah. Bring him as an offering upon one of the mountains which I shall tell you."

According to the commentary, God did not say, "slaughter him."

On the third day Abraham and Isaac arrived at the place that God designated. Abraham built the altar and arranged the wood on it. He bound Isaac and placed him on the altar, on top of the wood. And Abraham stretched out his hand, and took the knife to slaughter his son.

An angel of Hashem called him and said, "Do not stretch your hand upon Isaac, now I know that you are a God-fearing man."

And Abraham raised his eyes and saw there is a ram caught in the thicket by its horn so Abraham took the ram and offered it to Hashem.

Figure # 27

Chaye Sarah

Abraham was old. He summoned his servant Eliezer and told him to swear that he is not getting a girl to marry Isaac from the daughter of Canaanites, and told him to go to Abraham's family in the city of Nahor.

There have been many paintings by various artists, throughout history, about meeting of Eliezer with Rebecca by the well of water, outside of the city's gate.

He came to Nahor with ten camels and made the camels to kneel down outside the city over by the well of water at the evening time when women who draw come out.

And he said, "Hashem, God of my master Abraham, may you so arrange it for me this day that you do kindness with my master Abraham. Let it be that maiden to whom I shall say. Please tip over your jug so I may drink, and who replies, Drink and I will even water your camels. May the same be she that you have designated for your servant Isaac."

He hadn't yet finished speaking that suddenly Rebecca was coming out with her jug upon her shoulder.

According to commentaries, so great was her virtue that when she came to the well, a miracle happened and the water in the well ascended to meet her without her effort of pulling the jug up. After Eliezer drank enough water, Rebecca draw water for the camels. At this point the miracle stopped and she had to pull the jug up so many times to fill the troughs so that all the camels can drink. But she did all that with a good heart and determination.

I did have a vision of this scene as Rebecca standing by the well and the water is coming out of the well like a fountain, while Eliezer is standing with ten camels by the trough and his wooden cane fallen from his hands in surprise. But because of the complexity of the painting, I was not able to create it. Below are two painting from this parsha.

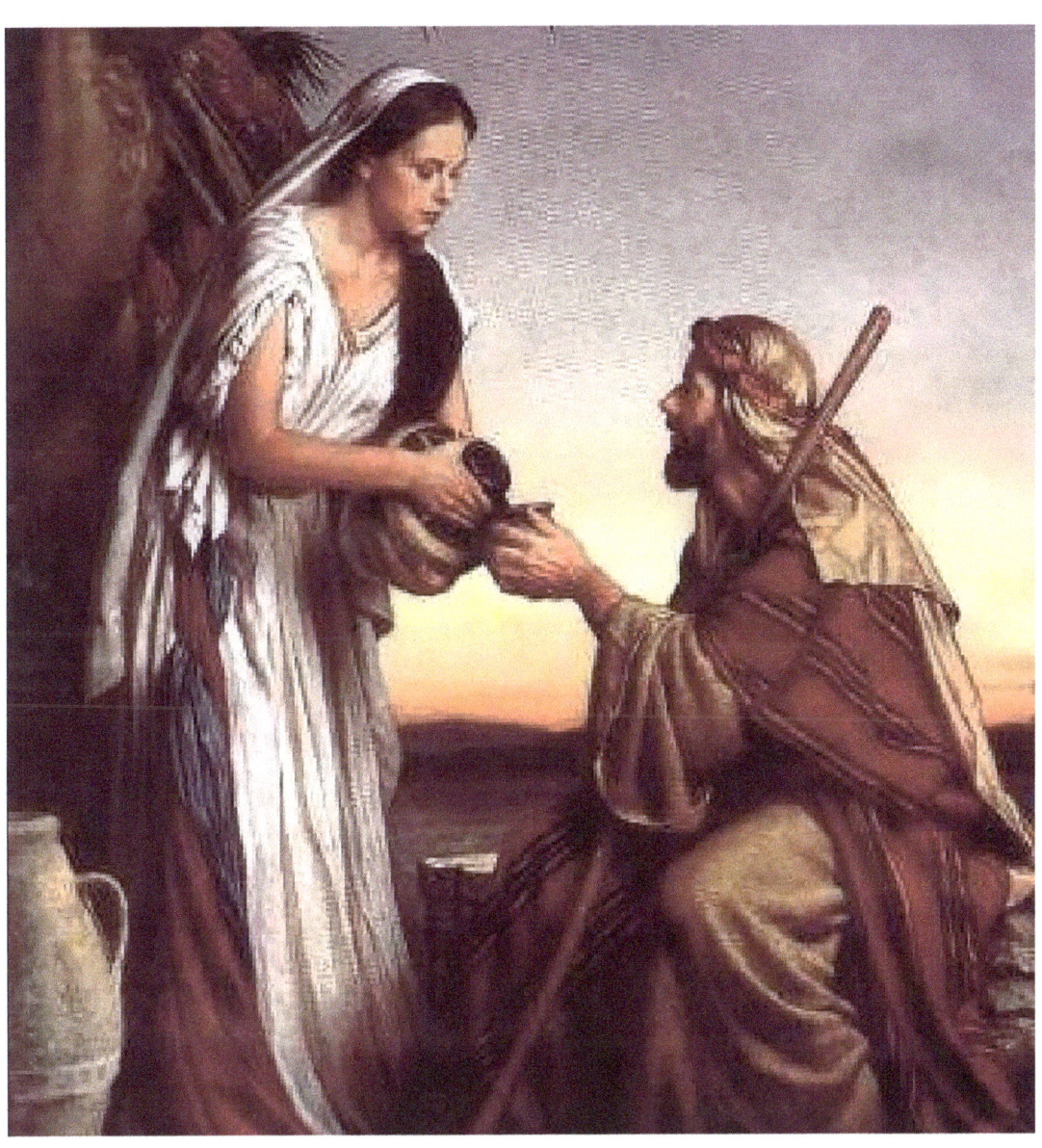

Figure # 28

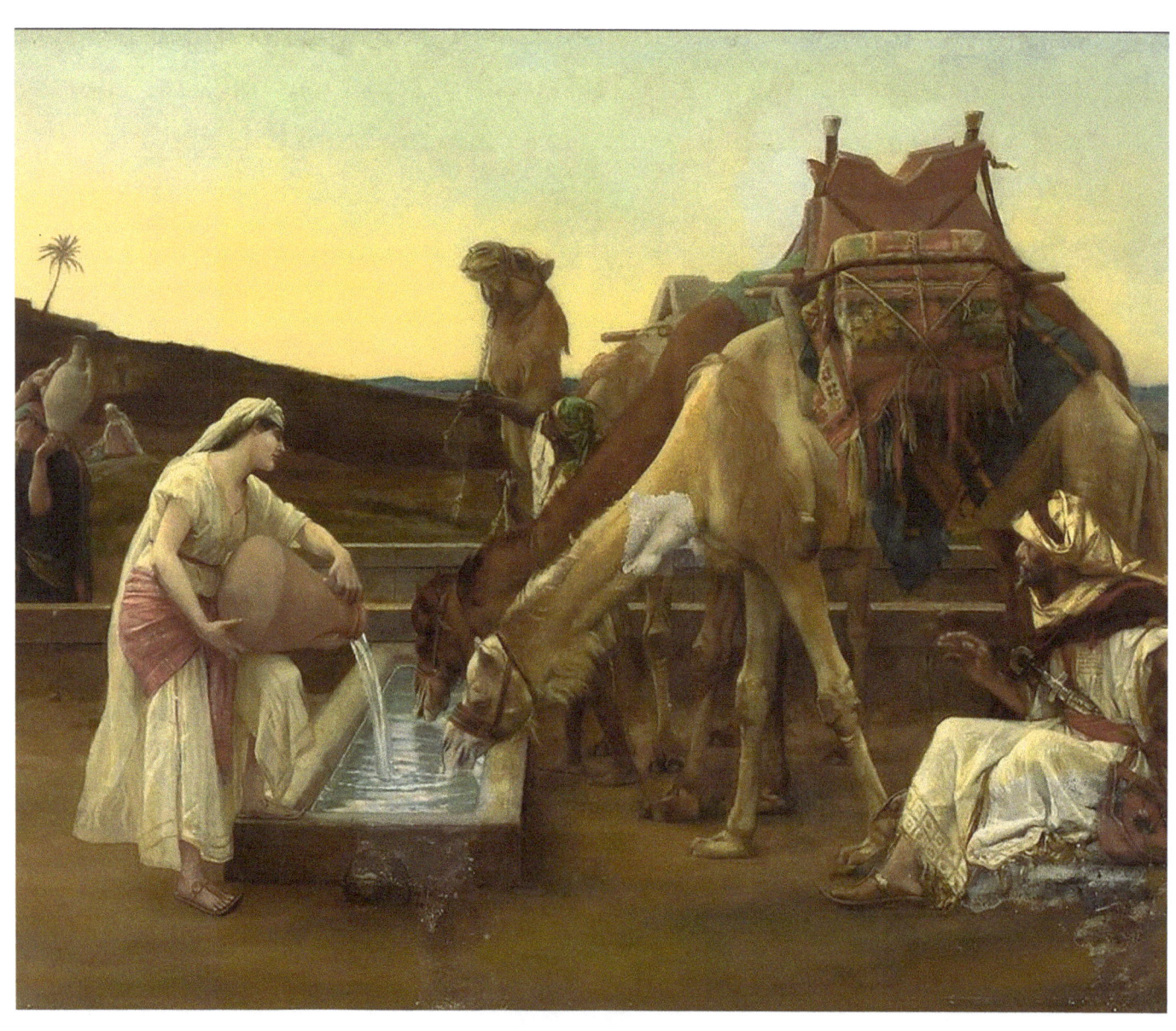

Figure # 29 This Painting is by a French Artist Name Alexandre Cabanel, Mid-1800

Vayeitzei

On the last parsha Toldot, we read that Jacob knew that his twin brother Esau is not worthy to receive the scriptures and be a leader of Israel so he was looking for an opportunity to buy the birthright from him. On the day that Abraham dies and everybody is mourning, Jacob is making a lentil stew for his father Isaac, according to the tradition for mourners. Esau comes in from the field tired and hungry and asks to have some of the red stew. Jacob asks Esau for his birthright in exchange of the stew and Esau sells it as he says, "I am about to die from hunger what good is my birthright for." Later when Isaac is old and looking to bless his children, Rebecca intervenes so that Jacob gets the proper blessing. So, Esau develops a hatred toward Jacob and woes to kill him. Rebecca hears about this and send Jacob away.

Jacob departs toward Haran where Rebecca's brother lives. At sunset he reaches Mount Moriah, 'where Abraham bound Isaac' and he lay down to sleep. And he dreams, and behold, a ladder is set earthward and its top reached heavenward, and behold angels of God ascending and descending on it.

In this painting I have shown the forefathers of Jewish nation. From left to right: Abraham, Isaac, Jacob, Moses, Aaron, and king David at the first row. Sons of Jacob And Rabbi Shimon Bar Yohai, editor of Zohar (Jewish mysticism) on the other rows as they ascended to heaven. Joseph is painted with a colorful prayer shawl separating him from the others. Angels are symbolized by white doves as they fly up and down the ladder. And the twists in the ladder represents the end of a dynasty and start of the other, such as Greeks, Romans, etc., which Jews lived under their rulership according to commentaries.

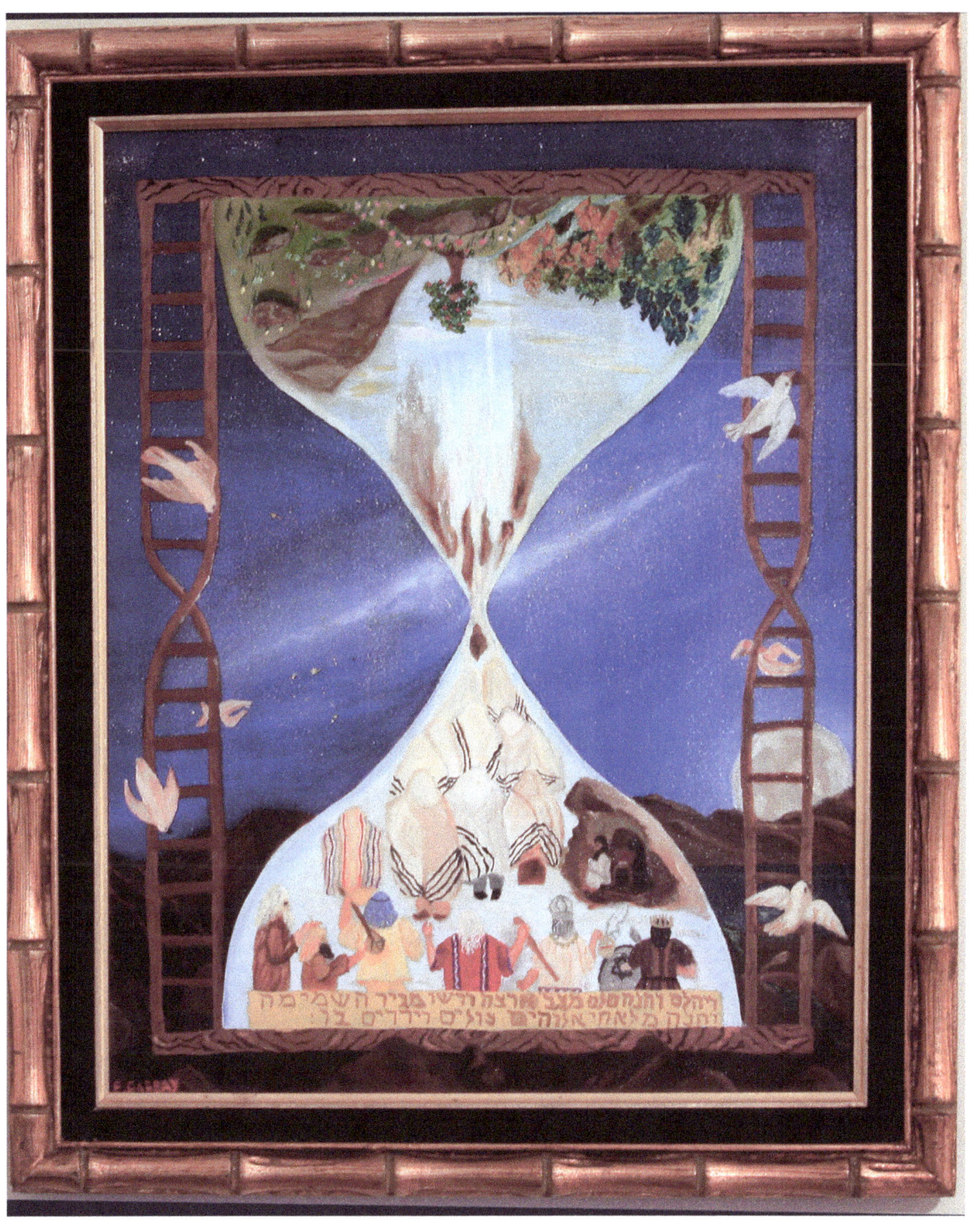

Figure # 30 9-Jacob's Dream 18x22

Vayishlach

After 20 years living and working with Laban, it was time for Jacob to move back with his wives and children. They came to a river and he sent his wives, children, and all his possessions across the river Jabbok. According to the commentaries, he left a few things so he came back to get them and he was alone. A man appeared and wrestled with him until sunrise. This man must have been the guardian angel of Esau. Esau is the symbol of evil inclination. Some say he was the Satan himself, who is always at war with higher spirituality and Godliness. Since Jacob was in a higher spiritual level, this guardian angel looked like a man to Jacob. We have the same similarities on Parashat Vayeira; when the three angels came to Abraham regarding the birth of Isaac and they looked like men, and when they got to Lot in Sodom, they were angels in Lot's eyes.

There are a few paintings and sketches by various artists which I include two in here.

After this fight Jacob met his brother Esau. There is a painting that shows Jacob and Esau hugging each other. Jacob has his eyes closed in prayer while Esau is looking at Jacob's wives and children.

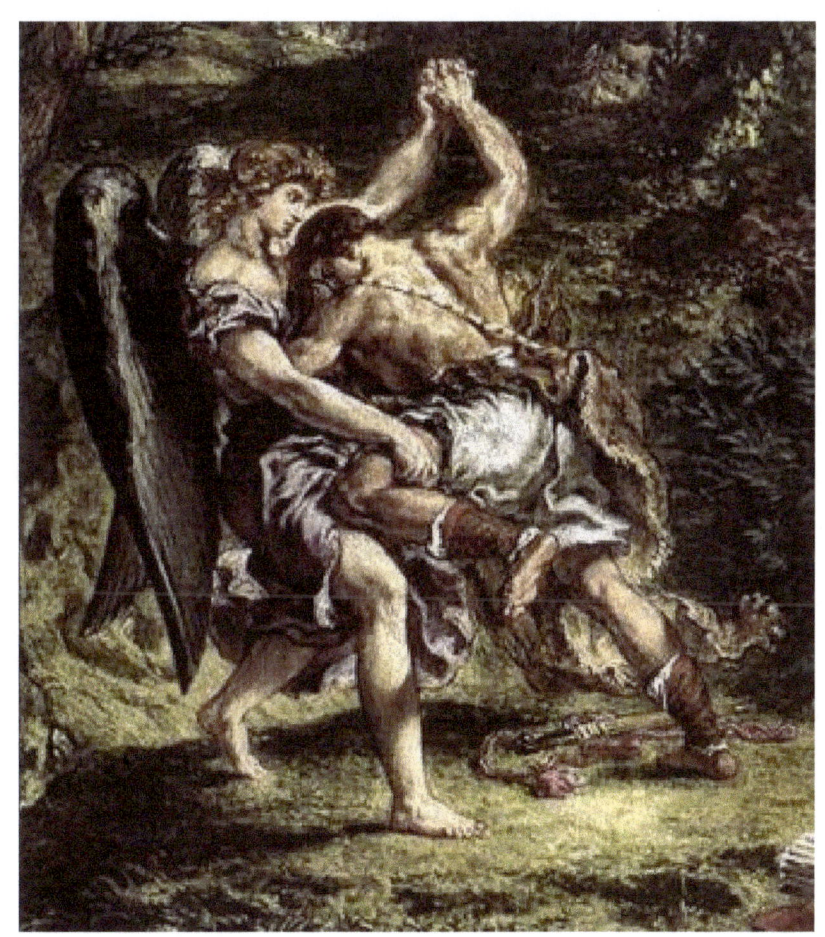

Figure # 31

Figure # 32

This painting is done by an Italian artist Francesco Hayez, a leading artist of Romanticism in the mid-19th century. Jacob is hugging Esau but since Esau was always a womanizer, he is looking at Rachel and Joseph is standing in front of Rachel for protection. Hayez other works mostly consist of portraits of famous people of his time. Another of his painting is 'the destruction of the Temple in Jerusalem.'

Figure # 33 Jacob Meets Esau

Vayeishev

Jacob settled in the land of Canaan permanently. It was nine years since he lost Rachel on the way to Canaan and Leah died about this time. Joseph was 17-years-old and Jacob loved him for two reasons. First, because Joseph was a wise son of Jacob and he taught him all that he learned at the academy of Shem and Eber before he went to the home of Laban. Second, since Reuben discredited himself by tampering with Jacob's bed, Joseph was elevated to the status of first born so Jacob made him a tunic of wool with colorful threads interwoven to indicate Joseph's leadership.

And the brothers hated joseph because of these reasons and because he was given bad report from them to Jacob. Although joseph was wise but he was immature enough not to sense his brothers' jealousy and tell them about his dreams.

Joseph's dream was a prophecy about his leadership and did have some elements of the famine in Egypt in the form of wheat that came after about 20 years. The brothers did bow to joseph after about 22 years when they came to buy food for the second time
bringing Benjamin with them.

"Behold, we were binding sheaves in the middle of the field, and behold, my sheaves arose and also remained standing then behold, your sheaves gathered around and bowed down to my sheaf."
"Behold, the sun, the moon, and eleven stars were bowing down to me."
In my version below I combined the two dreams. On the right corner, there is a well of water the one brothers throw Joseph in, also the Nile river and the Pyramids of Egypt.

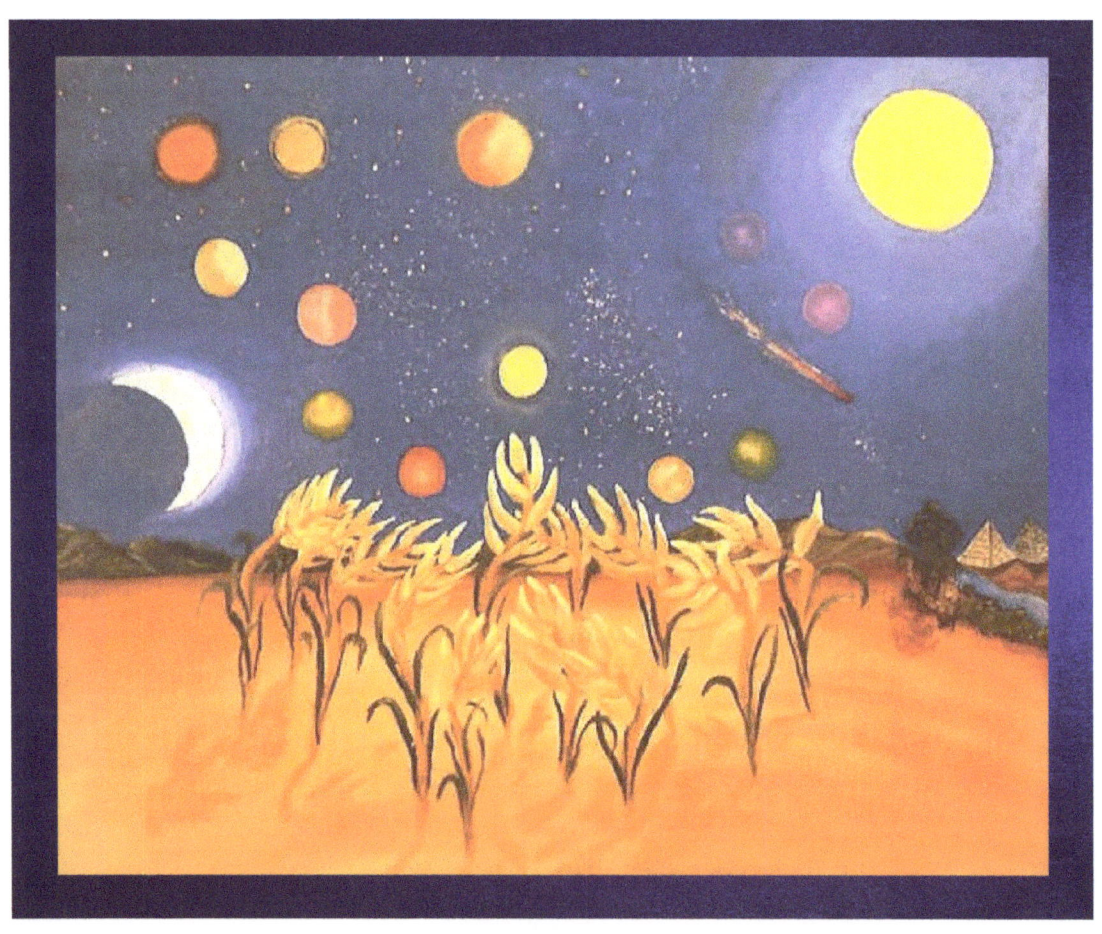

Figure # 34 10- Joseph's Dreams 18x22

As we all know Joseph's brothers sold him to a caravan of camels that were on the way to Egypt and he was sold to Potiphar; a courtier of Pharaoh. Joseph was a handsome man and was desired by his master's wife. There are few paintings about joseph and Potiphar's wife. This painting is by an Italian artist, around 1600, Guido Reni. Another of his painting is about David and Goliath.

Figure # 35 Joseph and Potiphar's Wife

Shemos

Jacob, his sons, and all their family move to Egypt because of the famine. Altogether, they were 70 souls and they settled in Goshen. Jacob lived 17 years in Egypt and he died. His sons buried him in the cave of Machpelah in Hebron. Joseph was a minister to Pharaoh for many years and he died at the age of 110. When all that generation passed away, a new king came to Egypt who did not care about all that Joseph and his generation had done for Egypt.

The king said, 'Children of Israel are becoming numerous so let us put them to hard work so they do not become stronger against us."

So, they appointed taskmasters and put children of Israel into bondage to make cities for Pharaoh, Pithom, and Raamses.

Astrologers warned Pharaoh that a Jewish boy will be born who will overthrow the kingdom. The pharaoh decreed that any boy who is born shall be killed.

Amram and Jochebed, parents of Miriam and Aharon separated because of this decree but Miriam argued that they should get together because they prevented even the birth of girls with their action. So, they got back together and Moses was born. Jochebed saw that the house became full of light so she knew that the boy was spiritually holy.

She kept him hidden for three months then put him in a waterproof wicker basket on the Nile between the reeds.

Pharaoh's daughter came to bath and found the basket. The maidservant stretched her hand and, miraculously, she reached the basket. Pharaoh's daughter saw there was a Jewish boy in the basket and she pity on him. There is a story that she was also afflicted with a skin disease that went away as soon as she opened the basket and touched Moses.

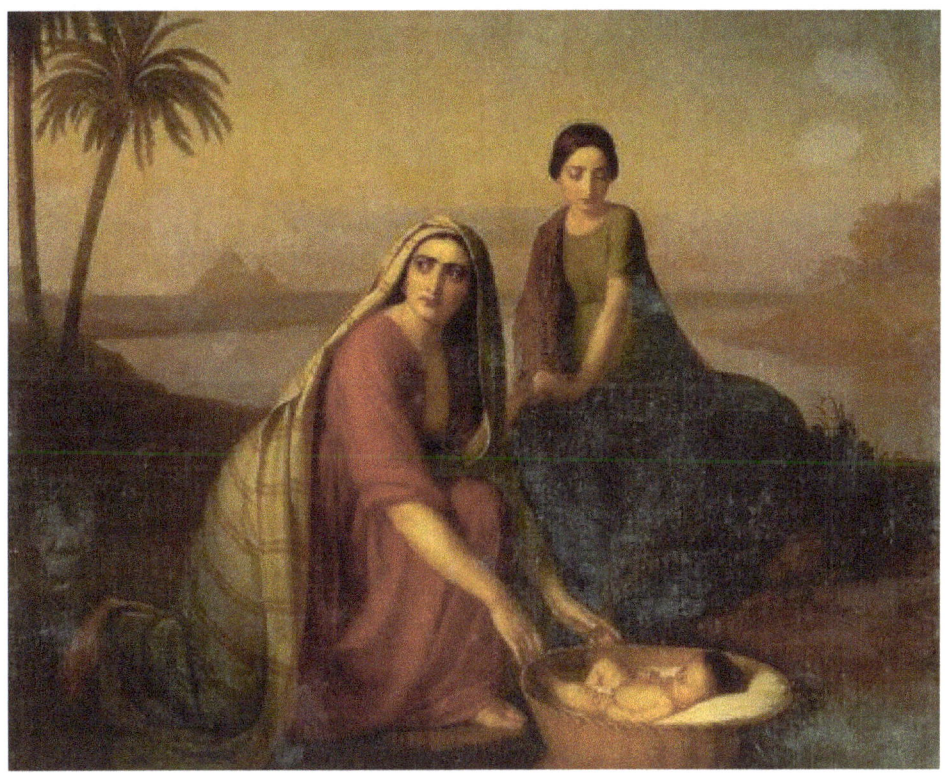

Figure # 36 Birth of Moses

The above painting is by Nicolas Poussin, a French Baroque style artist.

So, Moses grew up in Pharaoh's palace. He became a strong man mentally and physically, and founds out that he is a Jew. One day he saw an Egyptian beating a Jewish man violently and he killed the Egyptian. Then he ran away through the desert to Median. Later, he married Jethro's daughter Zipporah. Many years went by then, one day he was guiding the sheep of Jethro and he arrived at the mountain of God mount Sinai. An angel of Hashem appeared to him within a burning bush. He saw and behold; the bush was burning in the fire but it was not consumed. So, he got closer to see why the bush is not consumed then God calls out to him from within the bush.

The Parashat Shemot and the movie ten commandments has been a big inspiration for me. On my painting below, there is the burning bush where God appeared to Moses and the two tablets of the law. The Star of David is designed three-dimensionally, symbolizing Cohen, Levy, and other tribes. We are all interconnected and strong when we are united. The Shofar represents awakening. On the bottom is the Israelite camp on the other side of sea of reeds and the rock that provided water during the 40 years in the desert.

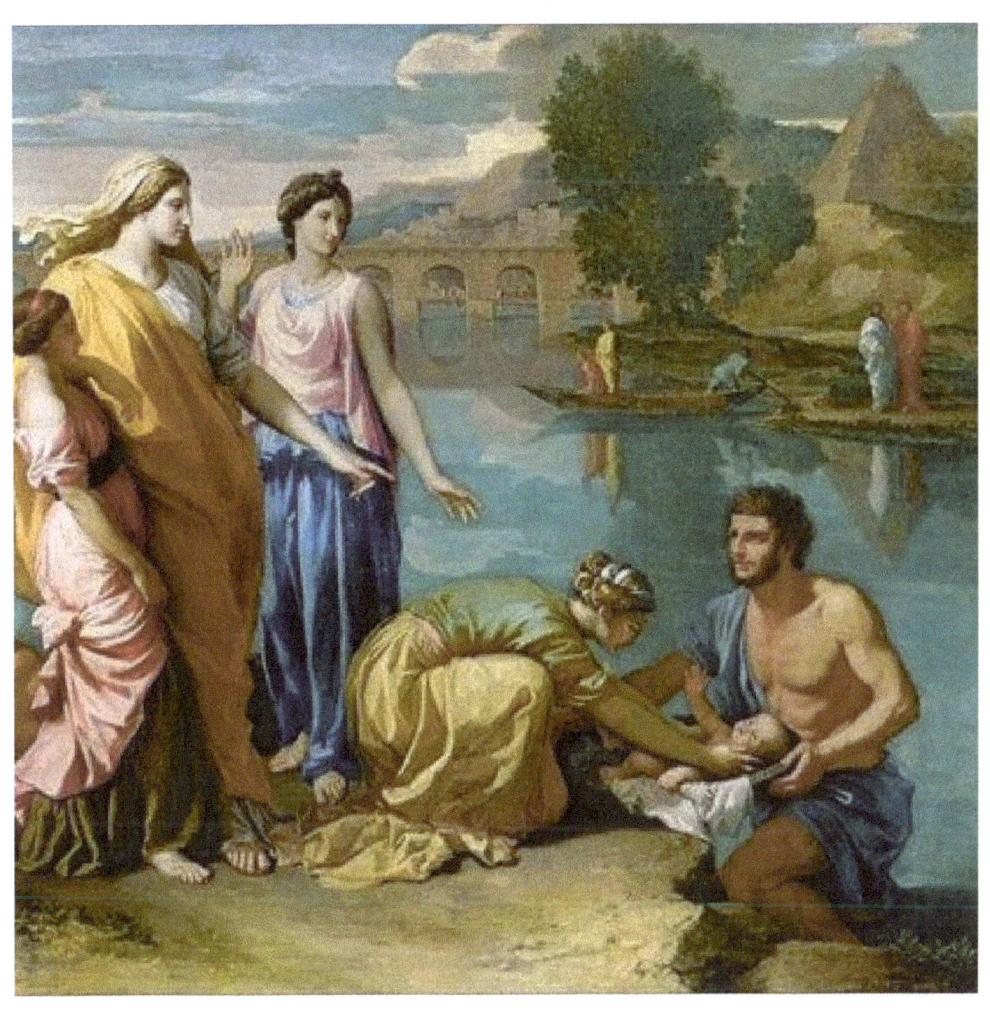

Figure # 37 Pharaoh's Daughter and Moses

In regard to ten plagues and opening of the Red Sea, there are many paintings in Passover Haggadah. So, we move to Parashat Yitro.

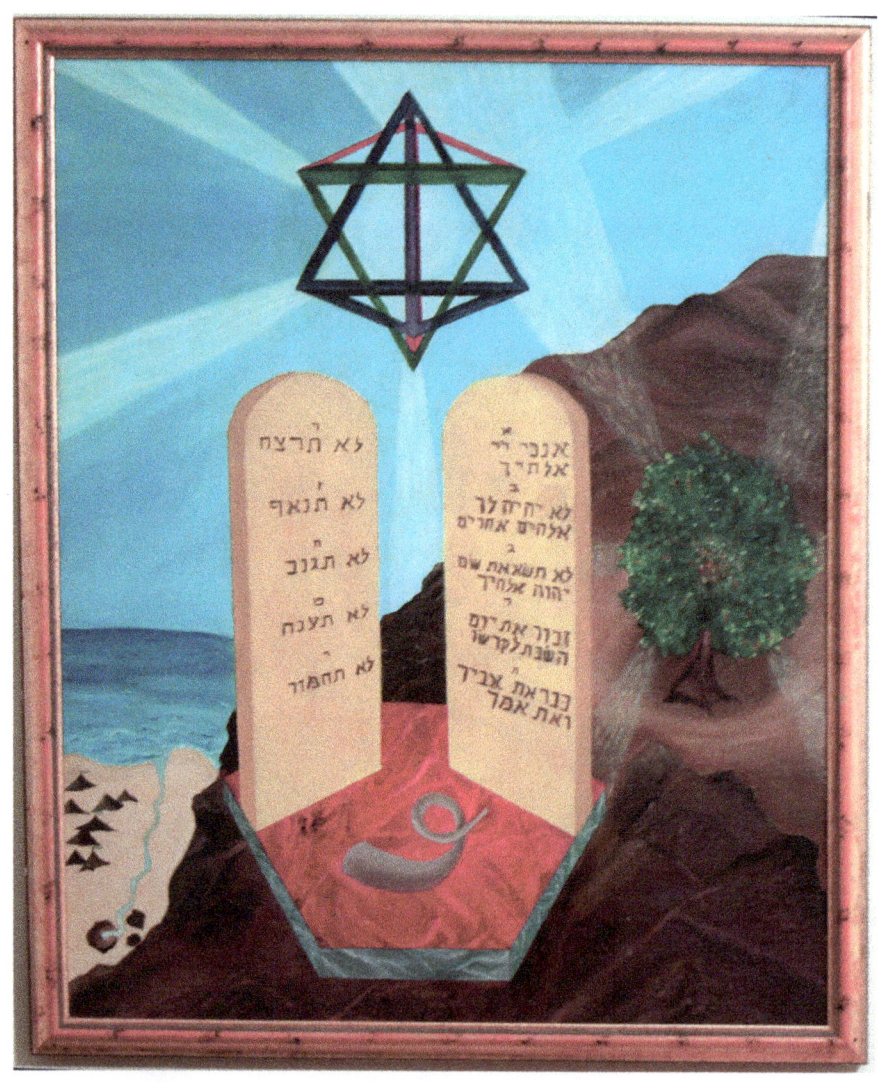

Figure # 38 11-The Ten Commandments 24x30

Yitro

In the third month from the exodus of the children of Israel from Egypt, they arrived at the wilderness of Sinai. On the third day, there was thunder and heavy cloud on the mountain, and the sound of shofar was very powerful. Hashem descended upon mount Sinai in the fire to present the ten commandments.

In this painting, there is lightning and fire on the mountain, and I made it look like a candle because a candle illuminates its surrounding. The candle also represent unity. On two sides there are the tablets of stone with ten commandments. Someone is playing a shofar and people have their hands up in prayer. The burning bush is also present in the painting.

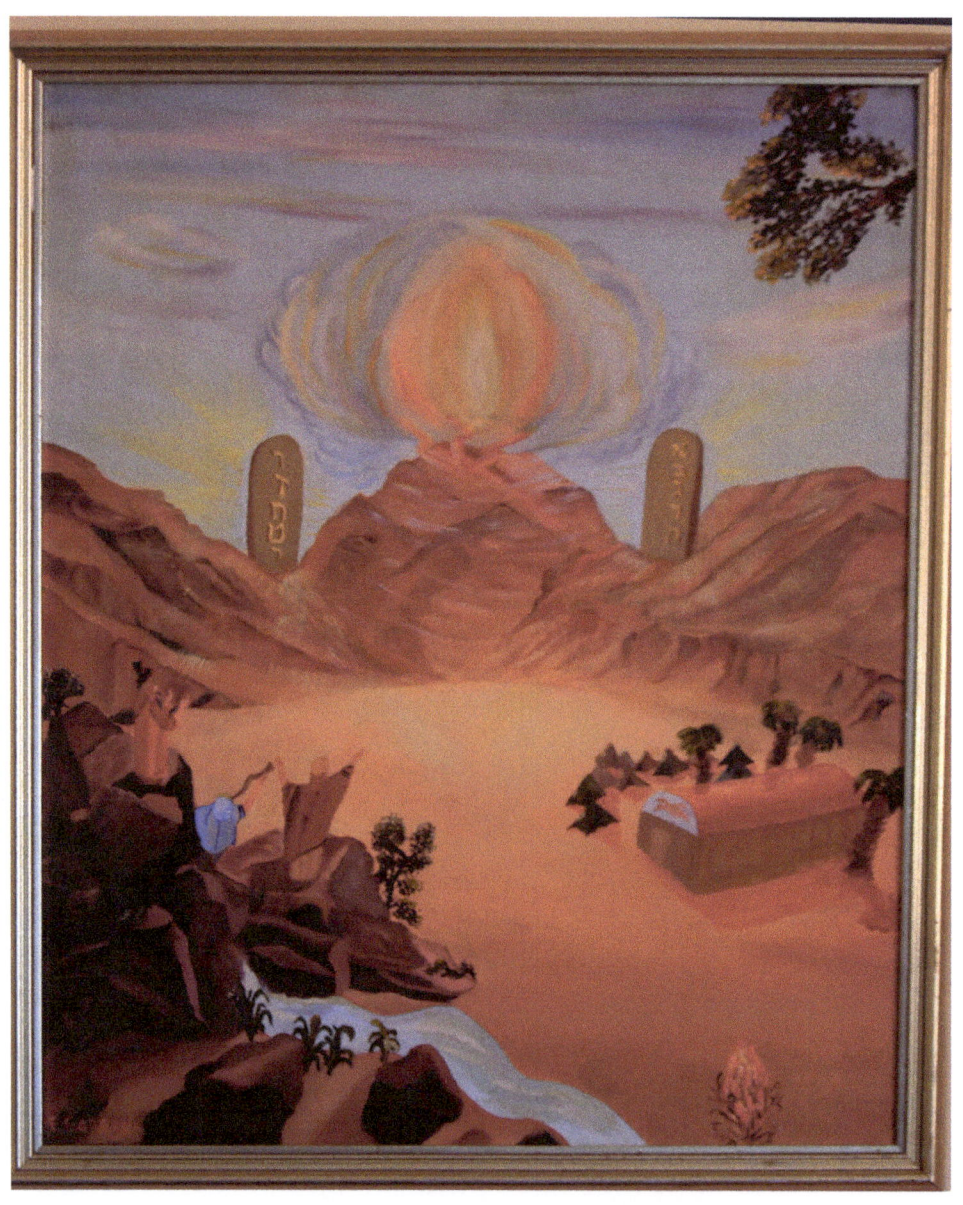

Figure # 39 12-Miracle at Mount Sinai 24x30

Terumah

In this parsha, God tells Moses to speak to children of Israel so they donate any material in the making of the tabernacle. And God describes all the pieces that the way it should be built. The Ark of acacia wood covered from inside and out with gold to place the Testimonial Tablets, written with the hands of God. The cover of the Ark has two cherubim with their wings spread on top of the cover, in the shape of a boy and a girl representing our children that will inherit and follow the commandments.

A Menorah of pure gold symbolizes the illumination of the intellect. The Menorah also represent the oral Torah which is a companion and complement to the written Torah. According to scripture, this menorah was so complicated that Moses was not able to visualize how it should be made. So, there was a miracle here; God told Moses to throw the gold into fire and out came the Menorah already made. We learn a lesson here that God wants us to do our best and then He comes in to help and complete the task.

Table of showbread, tabernacle of ten curtains in intermix colors of turquoise linen, purple and scarlet wool woven with cherubim design. Altar for burning sacrifices. A smaller altar for burning incense. And many other items to complete the tabernacle and the Holy of Holies placed in the center of the tabernacle and the courtyard.

Tetzaveh

In this parsha, God explains all the garments that needs to be made for Aharon and his sons who will minister as kohen. The breastplate was made from twelve stones representing each tribe.
The names of these stones do not match with some of the valuable stones we know at the present but some of the colors correlate with today's jewelry stones.

- Reuben, a red stone most probably a Ruby or Garnet.
- Simeon, a green stone probably Emerald, Jade or Malachite.
- Levi, a lined white black and red correlate with 'Peanut Wood' which is a fossilized wood.
- Judah, a sky blue maybe Topaz or Aquamarine.
- Issachar, midnight blue stone called Sapir or Sapphire.
- Zebulun, white stone white Agate.
- Dan Midnight Blue must be blue Lapiz Lazuli that has been used for thousands of years. It was also used by Egyptians in their artifacts.
- Naphtali, a black and white mixed stone must have been Snowflake Obsidian that is a volcanic glass stone.
- Gad bluish stone must be turquoise which is found in dry areas of the world and it had been used for 4000 years. It was used by the Egyptians.
- Asher Diamond.
- Joseph Shoham, stone a deep black color, must be onyx.
- Benjamin, a multi colored stone that is definitely Opal. Ethiopian opals had been in use for 4000 years and it is vibrant with lots of colors.

In this painting I visualized the Holy of Holies where the Ark located. The light represents illumination of Torah and also unity between all the tribes.

According to the scriptures, there were three separate curtains that is shown here with three sets of cubes and stairs. The floors consist of 12 colorful stones as of the signet stones for each tribe, accordingly. The other tile colors represent gold, silver, and copper according to the status of different people, rich middle class and poor.

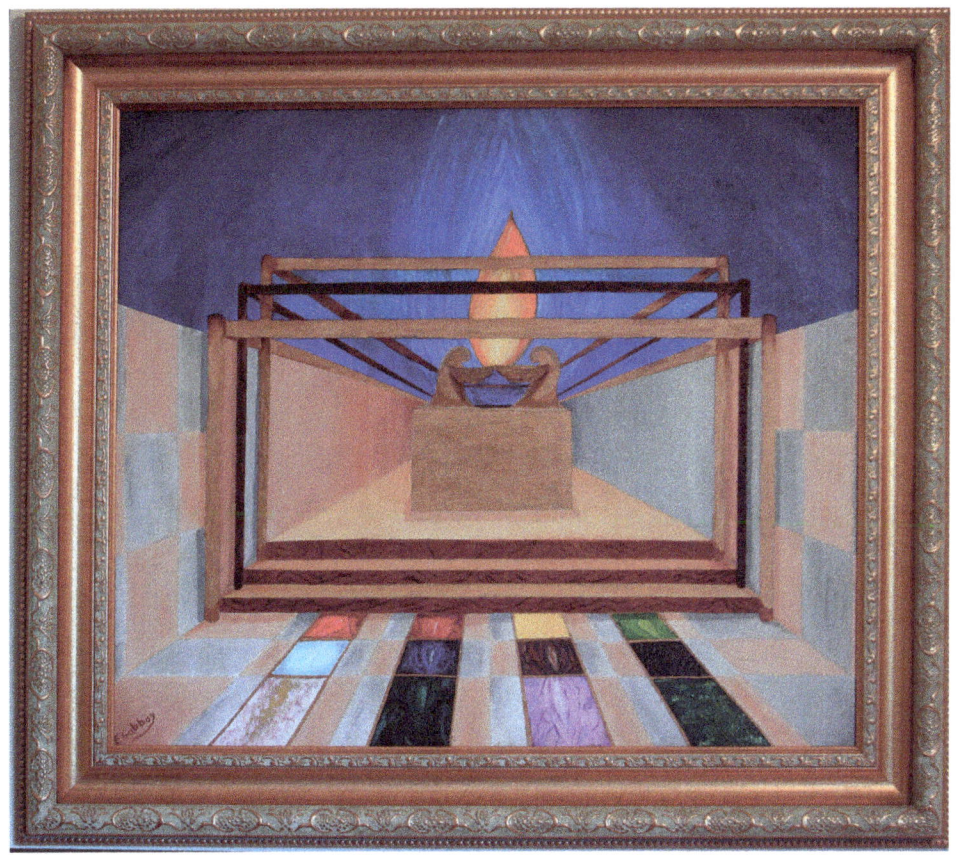

Figure # 40 13- Holy of Holies 18x24

I have painted many Menorahs that all represent light, wisdom, and unity between Jewish people and their interrelation toward each other.

In this painting I just used the color of rainbow to make the Menorah on a base of David Star. The branches are intermingled and in actuality a thing like this cannot exist three dimensionally. My idea is to represent Jewish people's existence after all the hardships and persecutions we faced, and are still standing strong in unity while so many other dynasties have perished and their countries changed to others.

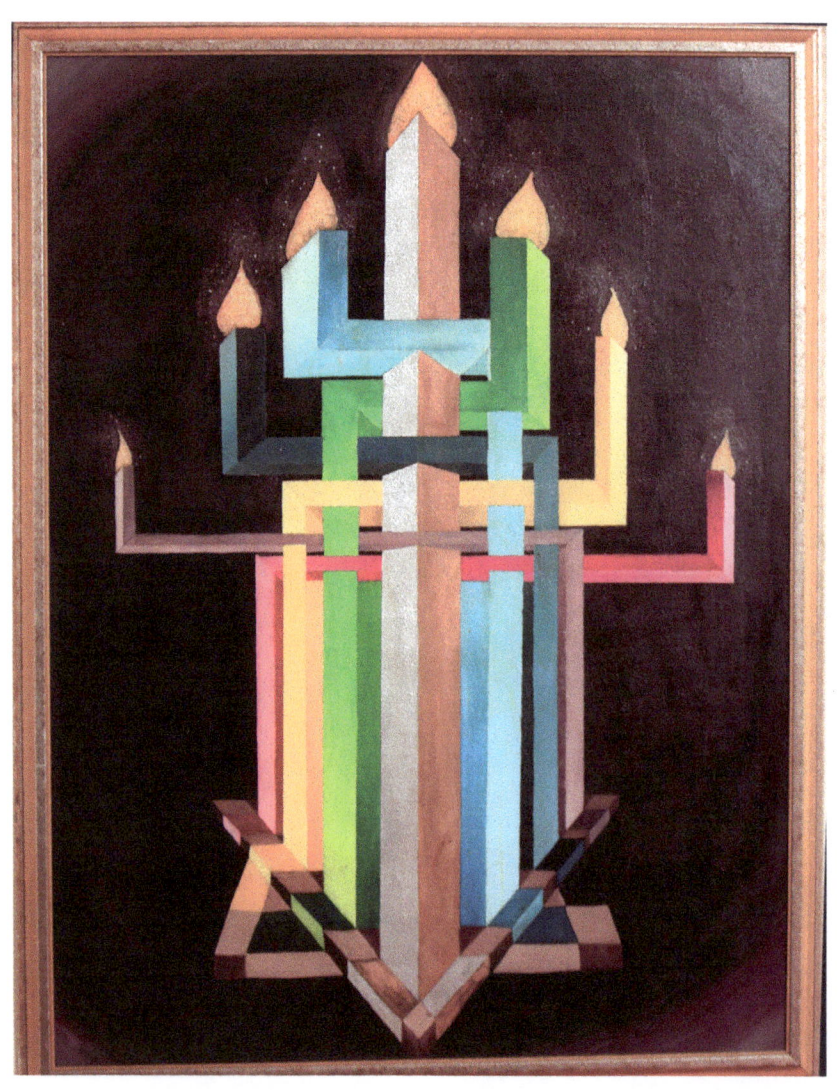

Figure # 41 14- Interwoven Menorah 30x40

This painting is about Hanukkah at the time that Hashmonaim came to the Temple and found one jug of oil to illuminate the Menorah, and that oil miraculously lasted for eight days until more olive oil was produced. The center branch represents God and each other branch consists of two tribes indicating that God is among us when we seek him. The color of the branches is according to the signet stones.

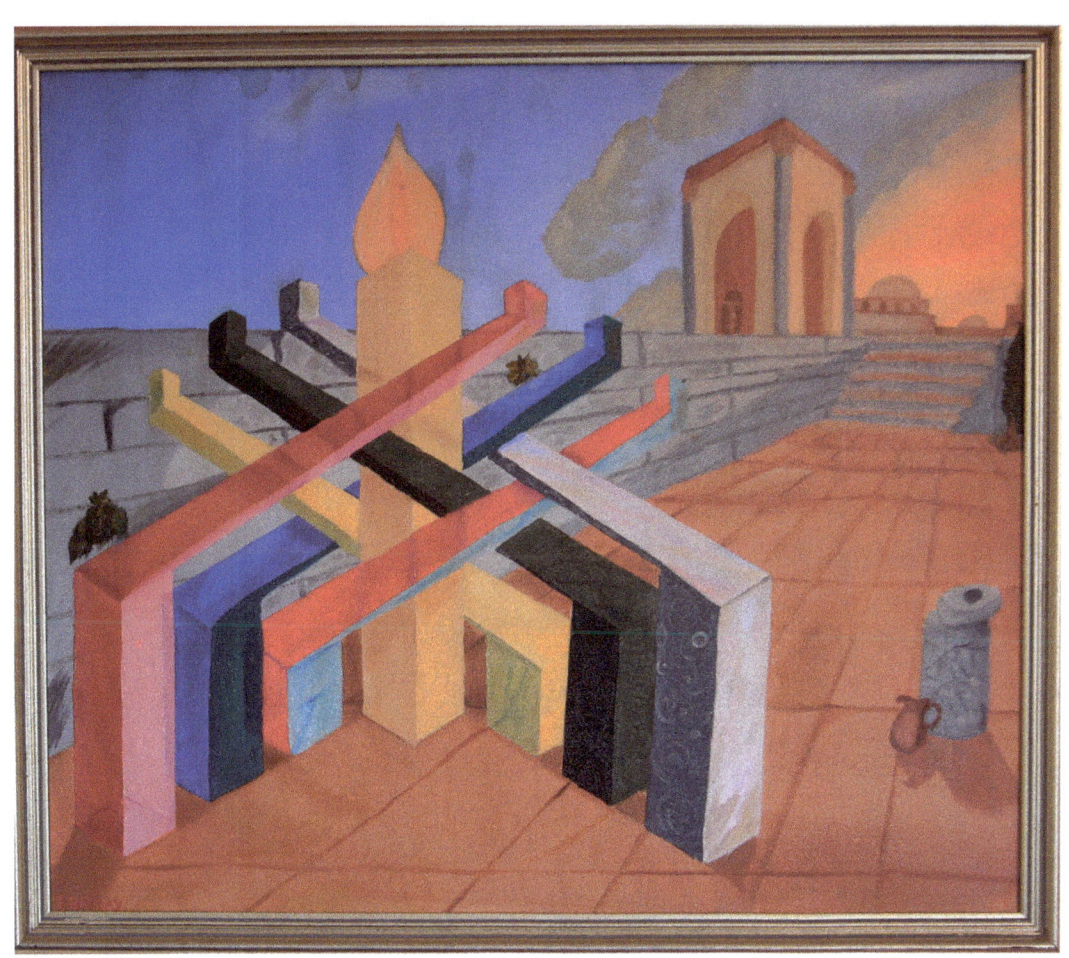

Figure # 42 15-The Last Jug 0f Oil

On this painting, the Menorah is an Ark in a synagogue, supporting the Star of David that is painted in the color of Israel's flag. The idea is that illumination of the Menorah and also Torah supports the land of Israel. I also included the bracha(Blessings) that comes from above at the time of Kohanim blessing in columns of light through the stained glass.

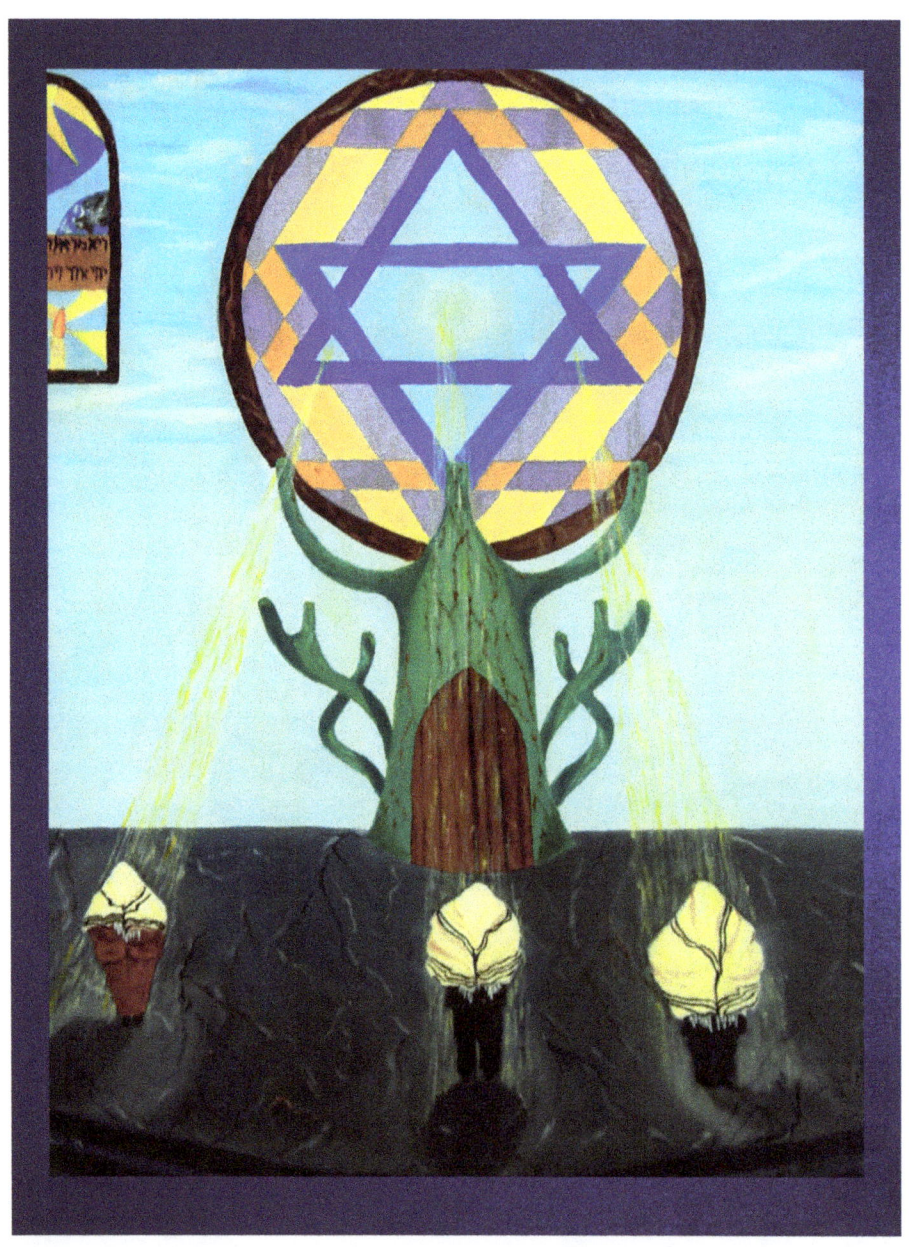

Figure # 43 16- Kohanim Prayern 18x22

Each color in this painting represents one aspect or population of Jews living in present day Israel. The background purple represents royalty and king David dynasty. Colors on the bottom, dark green represents Israel's soldiers from the green khaki they wear. White and black Orthodox and ultra-Orthodox. Gray regular not too religious population.
Blue and white tiles is for Israel's flag. Green branch of Menorah represents productivity. Yellow and brown is the color of the temple and red is for the fallen soldiers.

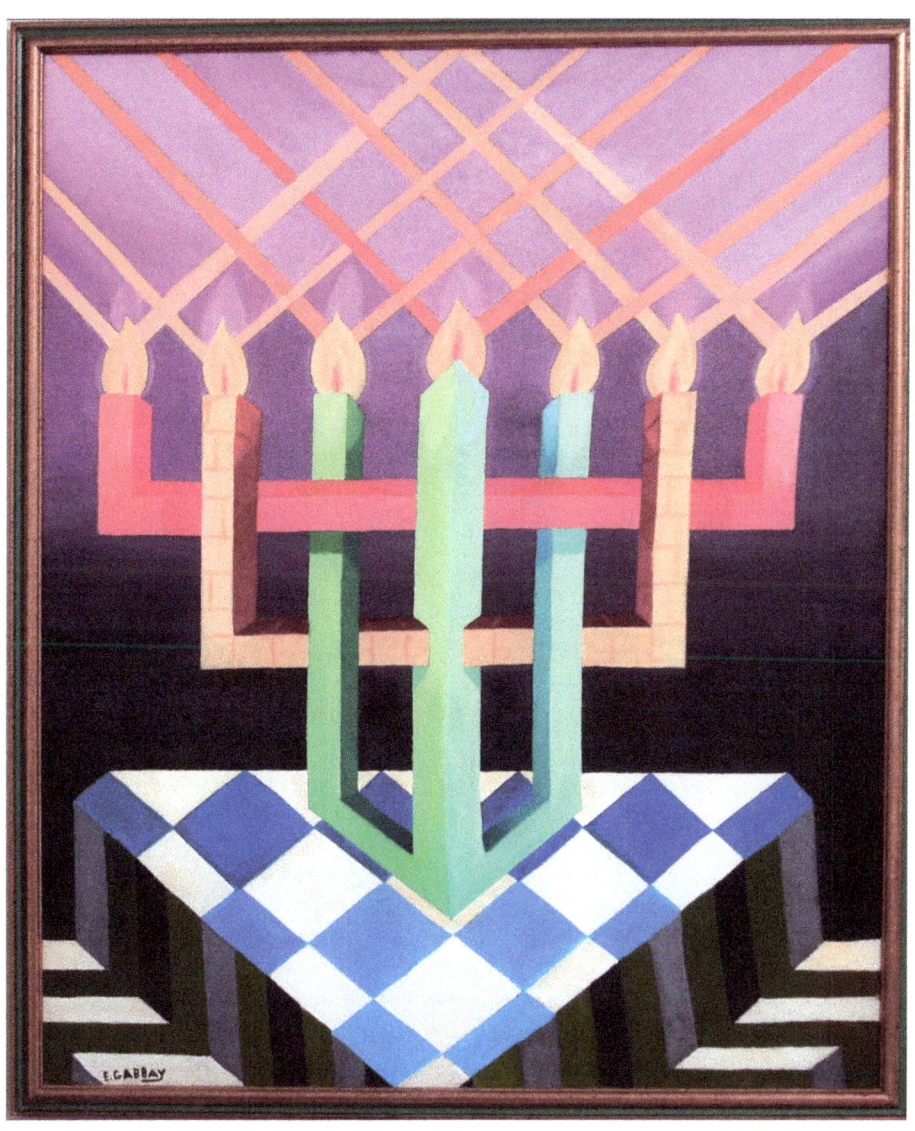

Figure # 44 17- Shining Menorah

The Arch of Titus

Below is the image from The Arch of Titus, located in Rome to honor the conquest of the Jews. It was built in 82 A.D. by the Roman Emperor Domitian, after the death of his older brother, Titus, to commemorate Titus' victories, including the Siege of Jerusalem, which destroyed the Second Temple. The Arch of Titus shows a stone carving of the menorah and other temple items carried by Jewish slaves in a parade in downtown Rome following the destruction of Jerusalem in 70 A.D. The menorah carved in the arch is the model for the menorah used as the emblem for the State of Israel.

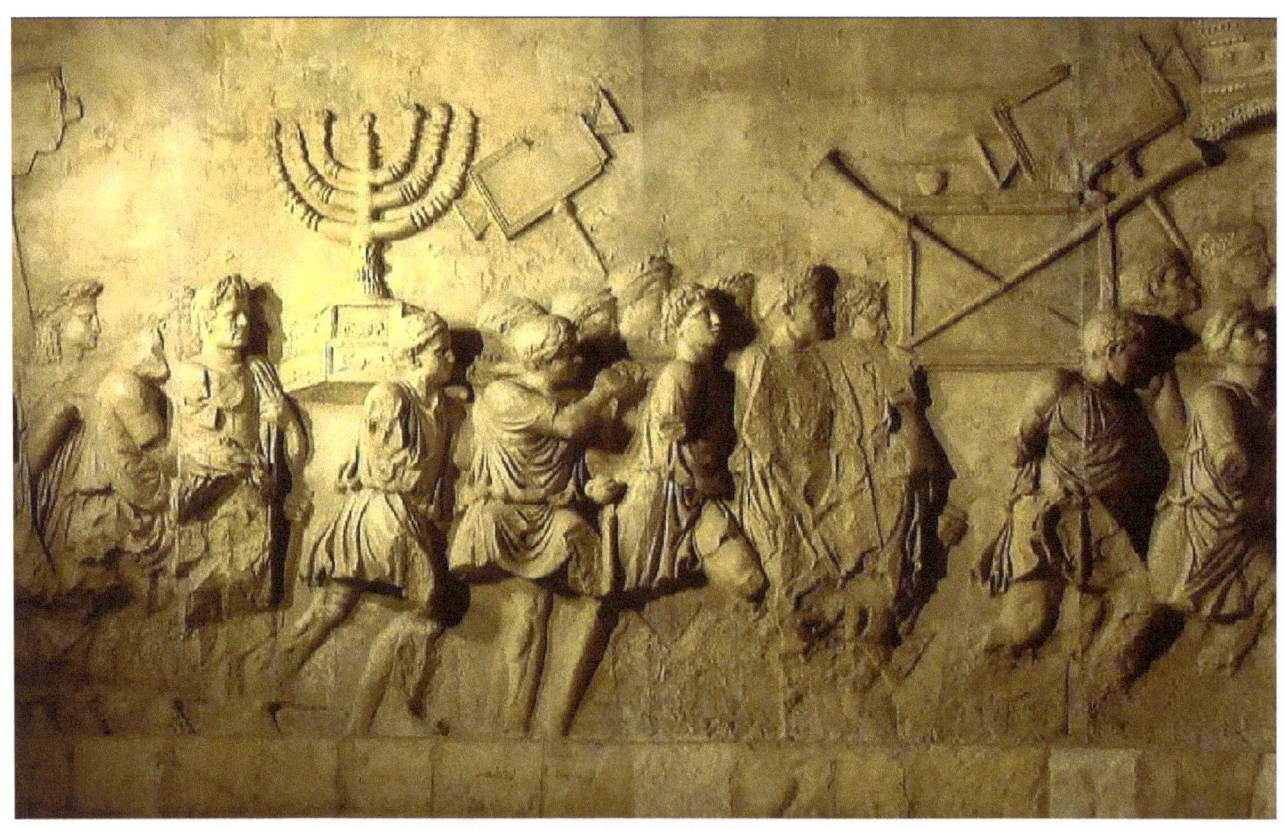

Figure # 45

At the end of this parsha is instruction to make an altar for incense, made of acacia wood and covered with gold. The altar must be placed

before the partition in front of the Ark that is in the center of Holy of Holies. Incense should be smoked in the morning and evening. On the High Holy Day of Yom Kippur service, the Kohen Gadol should start the smoke before he goes inside the partition to atone for people's sin. This smoke safeguards Kohen Gadol life because at that moment spirit of God fills up the Ark and the Holy of Holies.

As for the component of the holy incense:
1- Balsam 2- Onycha 3- Galbanum 4- frankincense 70 maneh each (maneh is about 2.5 or 3 pound) 5- Myrrh 6- Cassia 7- Spikenard 8- Saffron 9- Costus 10- Aromatic bark 11- Cinnamon

Some liquid called lye of Carsina, Cyprus wine, some salt of Sodom, little smoke raising herb and a little bit of Jordan resin.

All together there would be 368 maneh according to days of the year, plus 3 maneh for Yom Kippur service.

Balsam taken from a resinous tree and had some medicinal property.
Onycha: may have been the trapdoor of a sea snail, though some argue that since snail is unclean, the real onycha may have been a kind of annual rose buds. Onycha was rubbed with lye of carsina and steeped in white wine to remove the impurities and strengthen the fragrance.
Galbanum: resin is an aromatic Persian plant mostly grown on the north-west of Persia. It has a lot of medicinal property such as decongestant, detoxifier, anti-parasitic and more.
Frankincense: is produced by slashing the bark of a tree which grows in Somalia and northern Africa.
Myrrh is resin of a thorny tree produced similar to frankincense.
Cassia is an aromatic bark similar to cinnamon grown in East Asia.
Spikenard taken from a flower growing in northern China and Tibet. Have some medicinal values.

Saffron taken from pollen sack of a flower is aromatic and have some medicinal qualities.

Costus taken from a tropical plant from ginger family.

It is interesting that three of these ingredients, Myrrh, Cinnamon, and Cassia mixed with pure olive oil was used by Moses to make the oil to consecrate Aaron and his sons and all other Kohen Gadol who ministered at First and Second Temple. This oil made only once by Moses and was enough for all generations. Some believe there is a jug of this oil and Mana (the food that was coming from heaven during the 40 years in desert) buried somewhere in Jerusalem waiting for the Third Temple to be recovered.

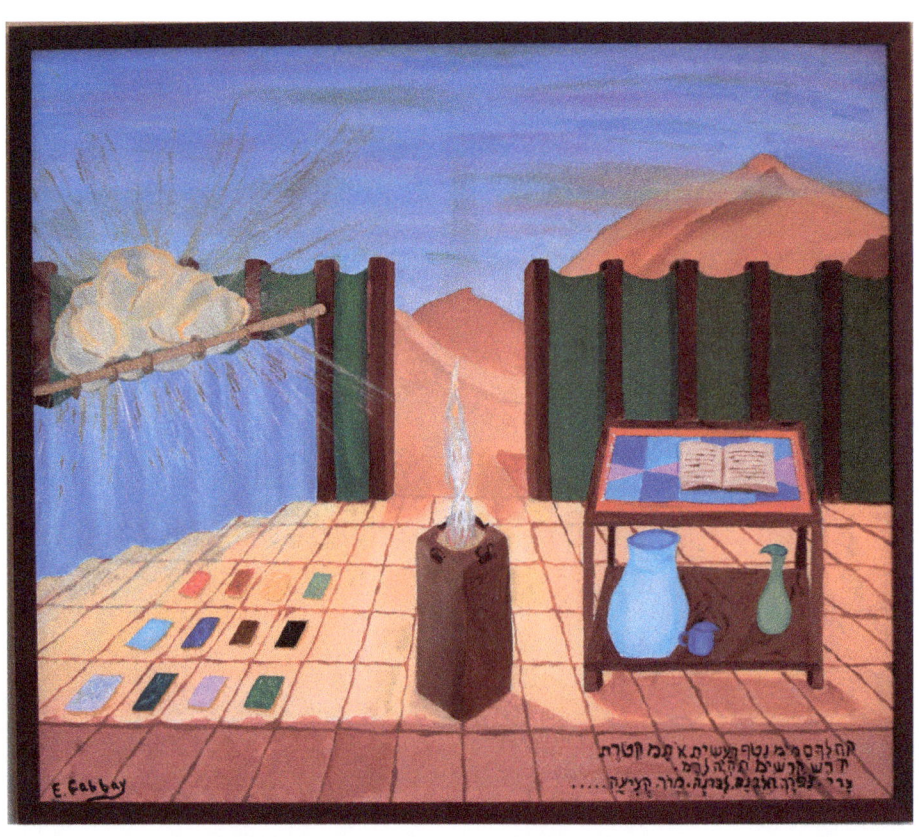

Figure # 46 18- Ketoret

Emor

In this Parsha, God speaks to Moses regarding the holy days during the year Pesach (Passover) and the way it should be celebrated; Rosh Hashanah, Yom Kippur, and Sukkot.

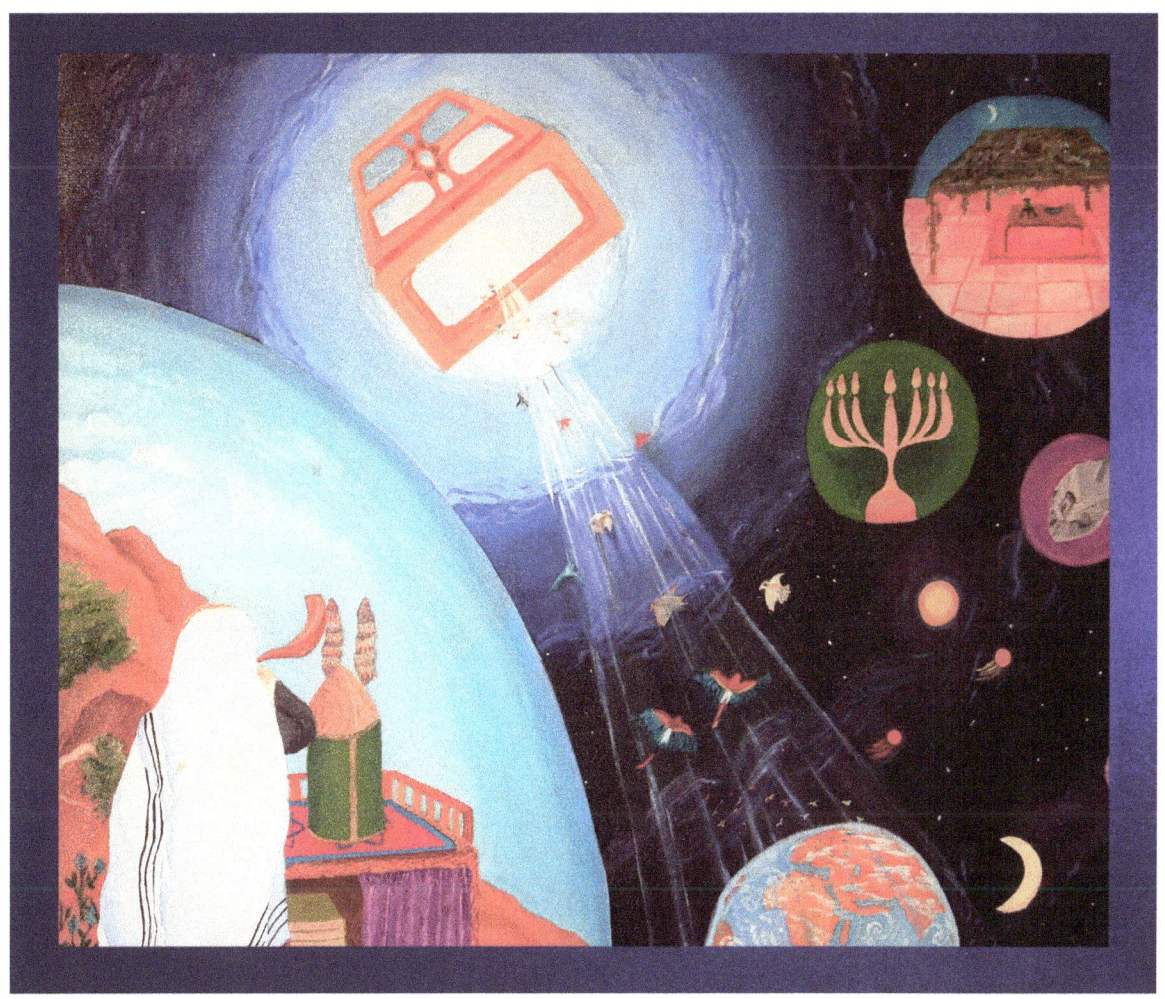

Figure # 47 19-Holy Days

In this painting I am referring to Rosh Hashanah, Yom Kippur, Sukkot, and Hanukkah. On these holy days, the doors of heaven are open to receive our prayers which are symbolized as different birds soaring up to heaven and the blessings that comes down to earth while the shofar is blasted.

Below is another painting in regard to Yom Kippur. In our service at the time of Neila that is on the sunset of the second day, we pray that God opens up doors of blessing for us.

It is sunset and the whole earth is standing in front of Torah, prayers fly toward heaven as birds, each bird opens a different door and blessings as shaft of light coming down to earth when the shofar is blown. There the same dove, bringer of peace, at the time of Noah is landing on the tablet of Torah.

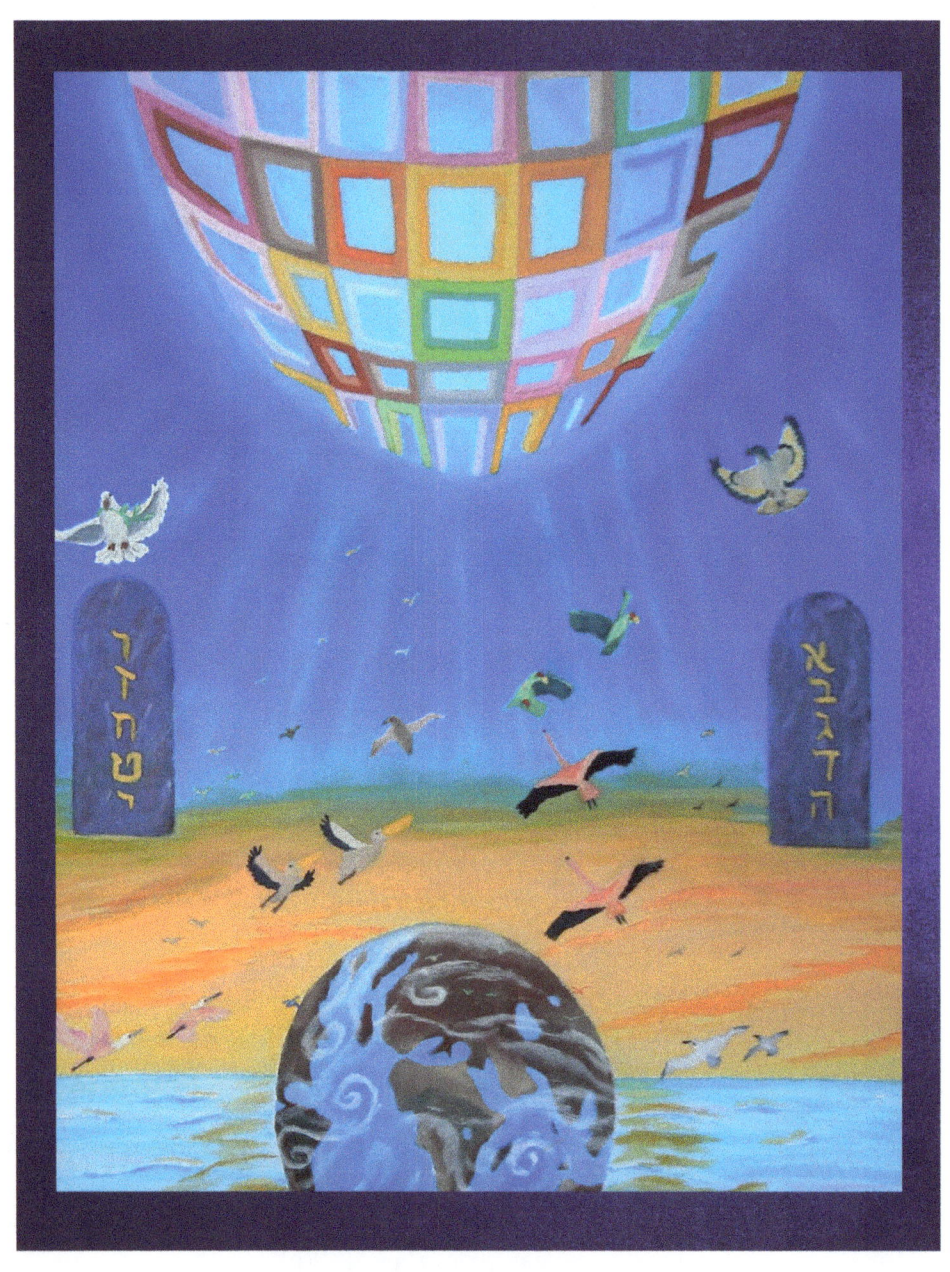

Figure # 48 20- Neila 18x24

Behar

In this Parsha, God tells Moses to speak to children of Israel to keep the year of Shemitah. For six years you may work your field and in the seventh year, there is a Sabbath for the land. And God will increase your produce as much that people will have enough to eat on the sixth, seventh, and part of the eighth year. This indicates that you have to have faith in God and he is the one that controls
and provides everything.
After seven cycle of Sabbatical years, the 50th year is the year of Jubilee and proclaim a year of freedom throughout the land.

This painting above contains 50 heptagons representing year of jubilee after 49 cycle of seven years. The three-dimensional Star of David encompasses the cycles. God's blessing comes from above the blue triangles, the place where the viewer see the painting from.

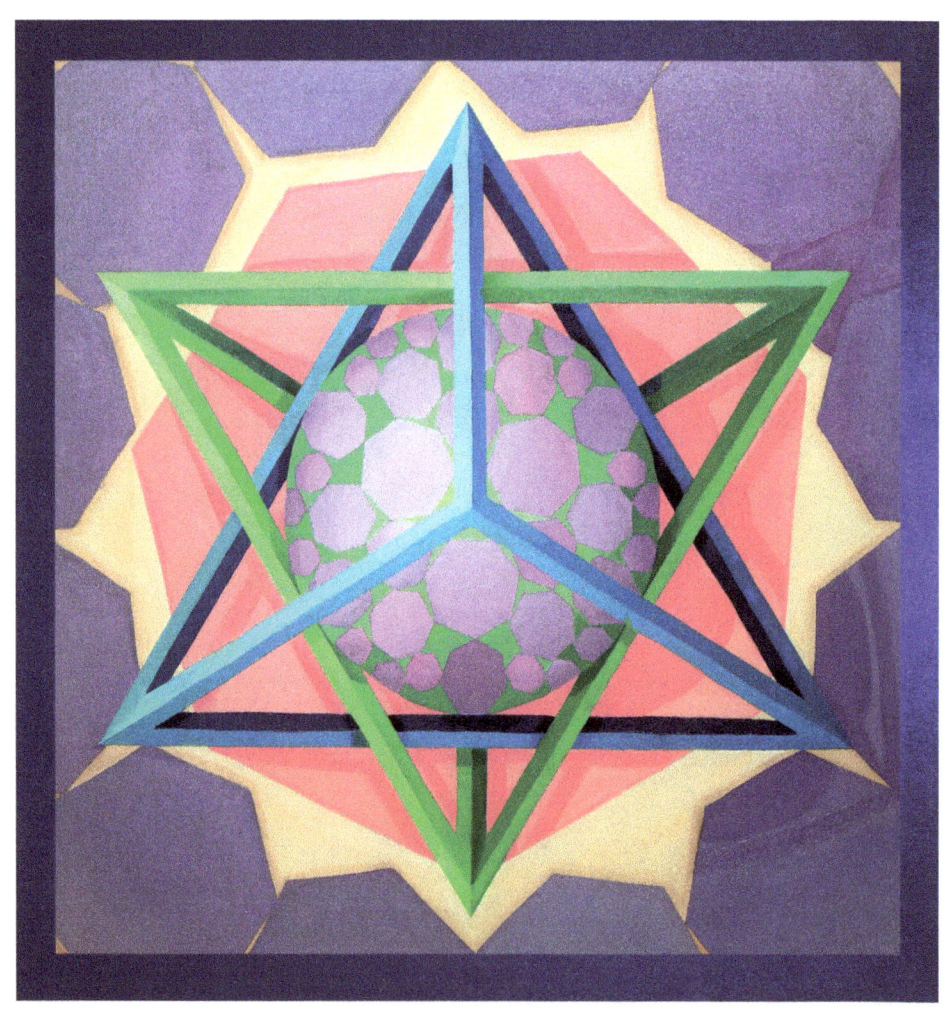

Figure # 49 21-Jubilee 30x30

Chukas

We move up many parshas and get to parshas chukas about 38 years after leaving from Egypt. Children of Israel arrive at wilderness of Zin. Miriam died there and buried, and there was no water to drink. People gathered around Moses and Aaron complaining why they came to this place without water.

It was in the merit of Miriam that the miracle rock followed the tribes in the wilderness and supply them with water, the same rock that supplied Hagar and Ishmael in the desert. The reason that the rock stopped giving water because people did not mourn for Miriam's death. Moses and Aaron went away from the congregation to the Tent of Meeting. Glory of God appeared to them. Hashem spoke to Moses, saying, "Take the staff and gather the congregation and speak to the rock that it shall give water."

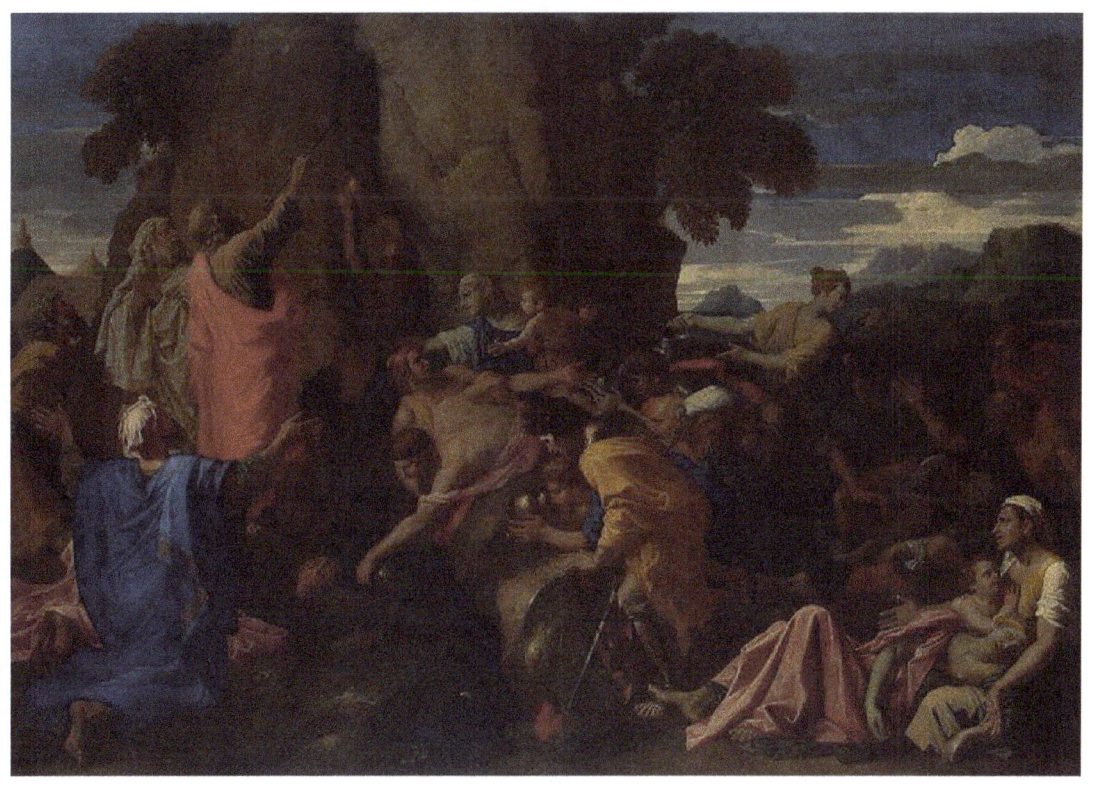

Figure # 50

In this case Moses made a mistake and the miracle didn't happen the way God wanted so that people's faith became stronger to God. Moses was not supposed to struck any rock with his staff. Although God told him to take his staff with himself, but He only had to speak to rocks in the area that the special rock was hidden until the rock gives water. But since he was angry with the people, he just chose a rock and struck it twice with his staff.

This painting was also done by Nicolas Poussin during 1600s.

Va'eschanan

Safeguard the Shabbat day to sanctify it, as Hashem, your God has commanded you.

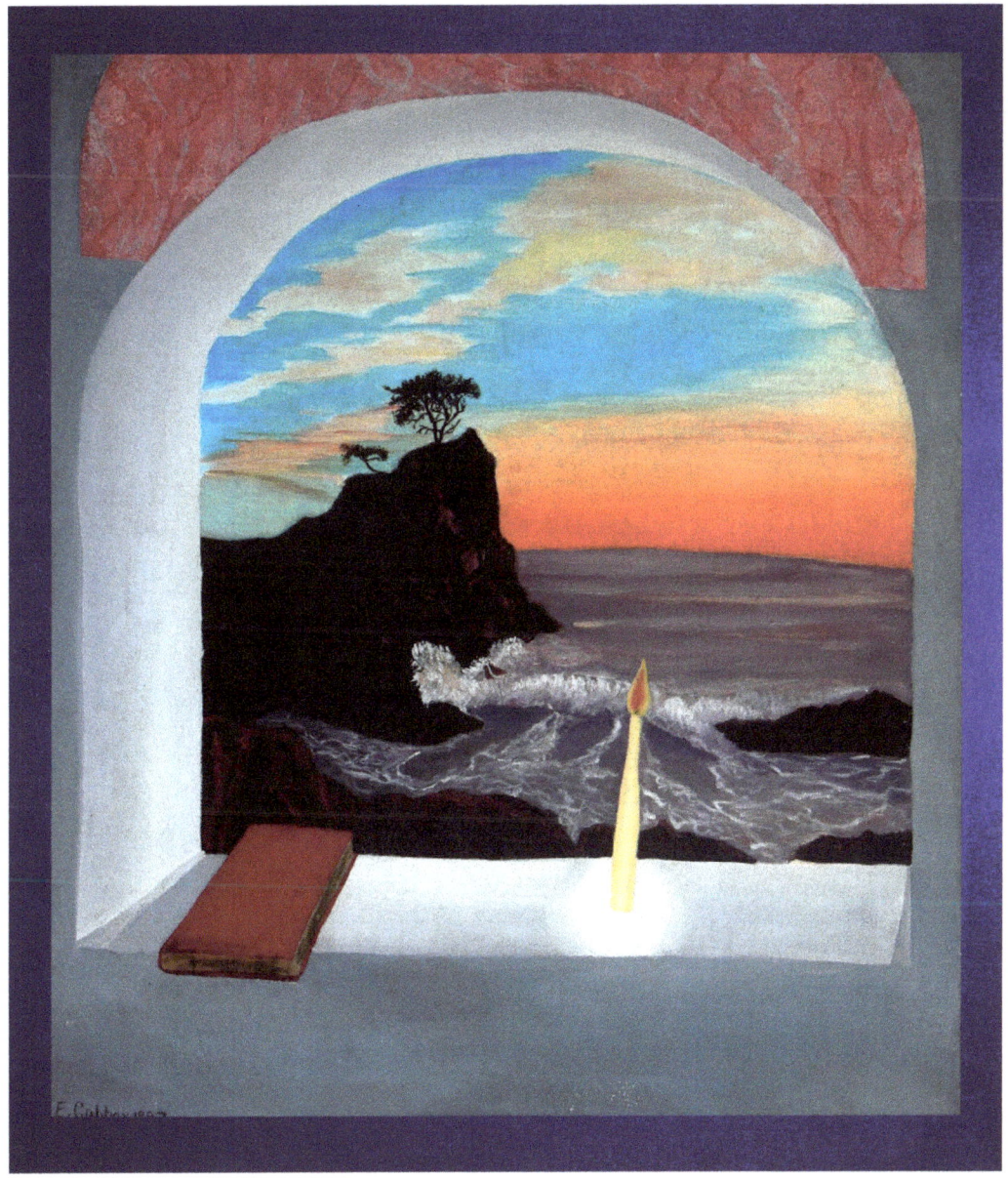

Figure # 51 22-Shabbat 20x24

The above is a simple painting of sunset with prayer book and Shabbat candle on a window sill. I choose the background as the famous lone cypress located in town of Carmel in California.

From this parsha onward, Moses speaks about laws and obligations in details that people should follow when they enter into the land of Israel in order to be prosperous in life with health and happiness. He indicates if they follow all the commandments, they will live in peace and will be a holy nation for God and in the face of all other nations.

I got some inspiration from the everyday Siddur that we read and pray. At the last line in Aleinu Leshabeach we read "At the end of days Adonai will be king over all the world; On that day Adonai will be One and his Name One."

This has come in the prophecies of Isaiah:

"It will happen in the end of days: The temple of Hashem will be exalted, and many nations will stream to it to learn and walk in the path of God. Because from Zion will the Torah come forth, and the word of Hashem from Jerusalem."

"He will judge among the nations, and will settle the arguments of many peoples. They will beat their swords into plowshares and their spears into pruning hooks; nation will not lift their swords against nation and they will no longer study warfare."

In one of the commentaries I read, and in addition to this saying, Lion will lie down with sheep, and the name of Zion will be over all the oceans.

In this painting, I painted the Ark of testimony, symbolizing the temple and people praying by the wall. There is a Star of David across the ocean. The brown mountain is mount Fuji in Japan indicating spread of Zion and name of God over the world, and a deer and jaguar side by side peacefully.

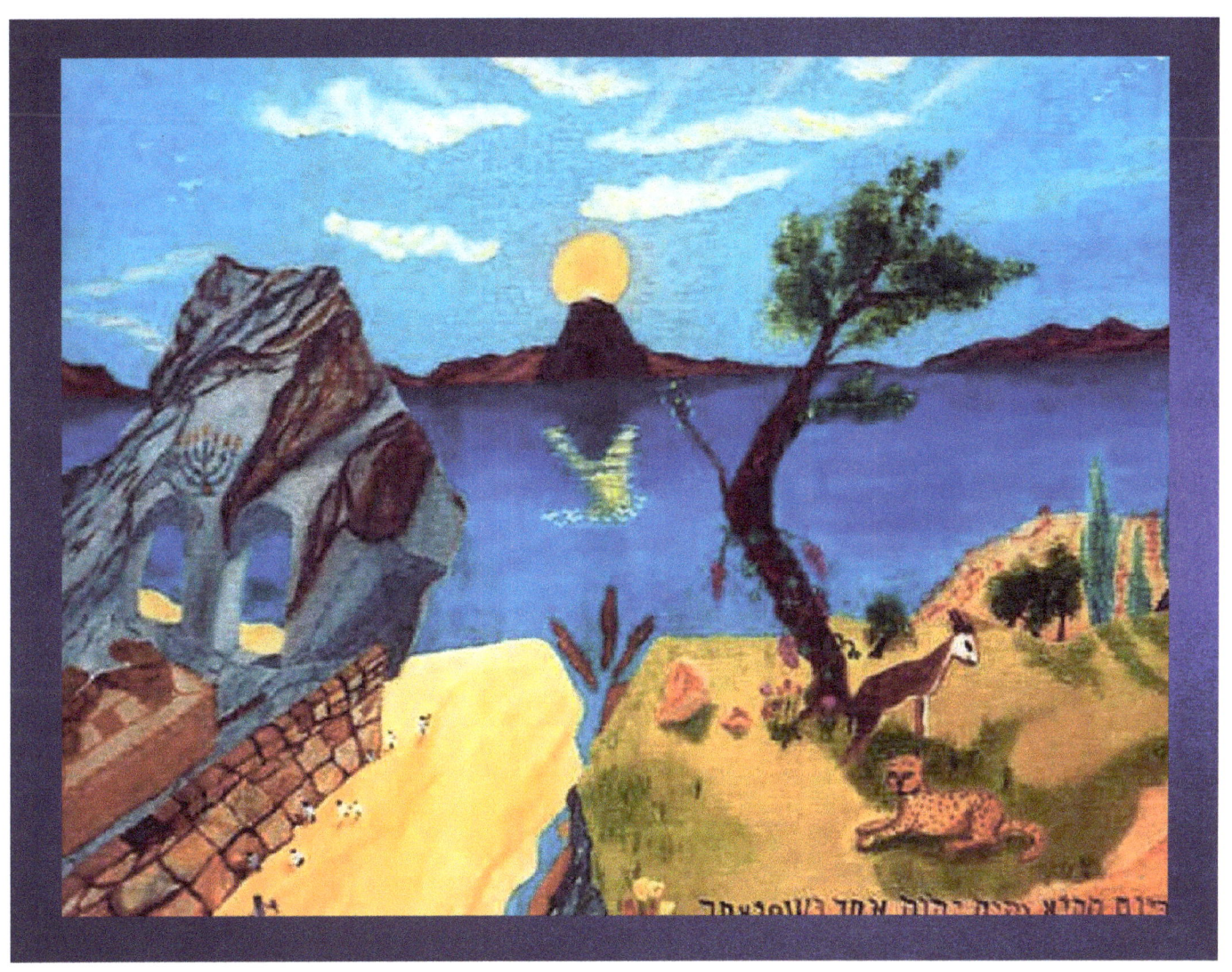

Figure # 52 23 -At the End of Days 18x22

Some of my other paintings are taken from tragedies happened during the 20th century or 21st century. Another one is about nature that affects the relationship between man and woman in marriage.

I have always had a love for the Star of David and made a few geometric abstracts. The painting on the cover, Jubilee and the painting below. I included Star of David in another surrealist work to show God's love for his chosen people, and a painting that shows God's protection for life on earth and perhaps on other planets throughout this vast universe He has created.

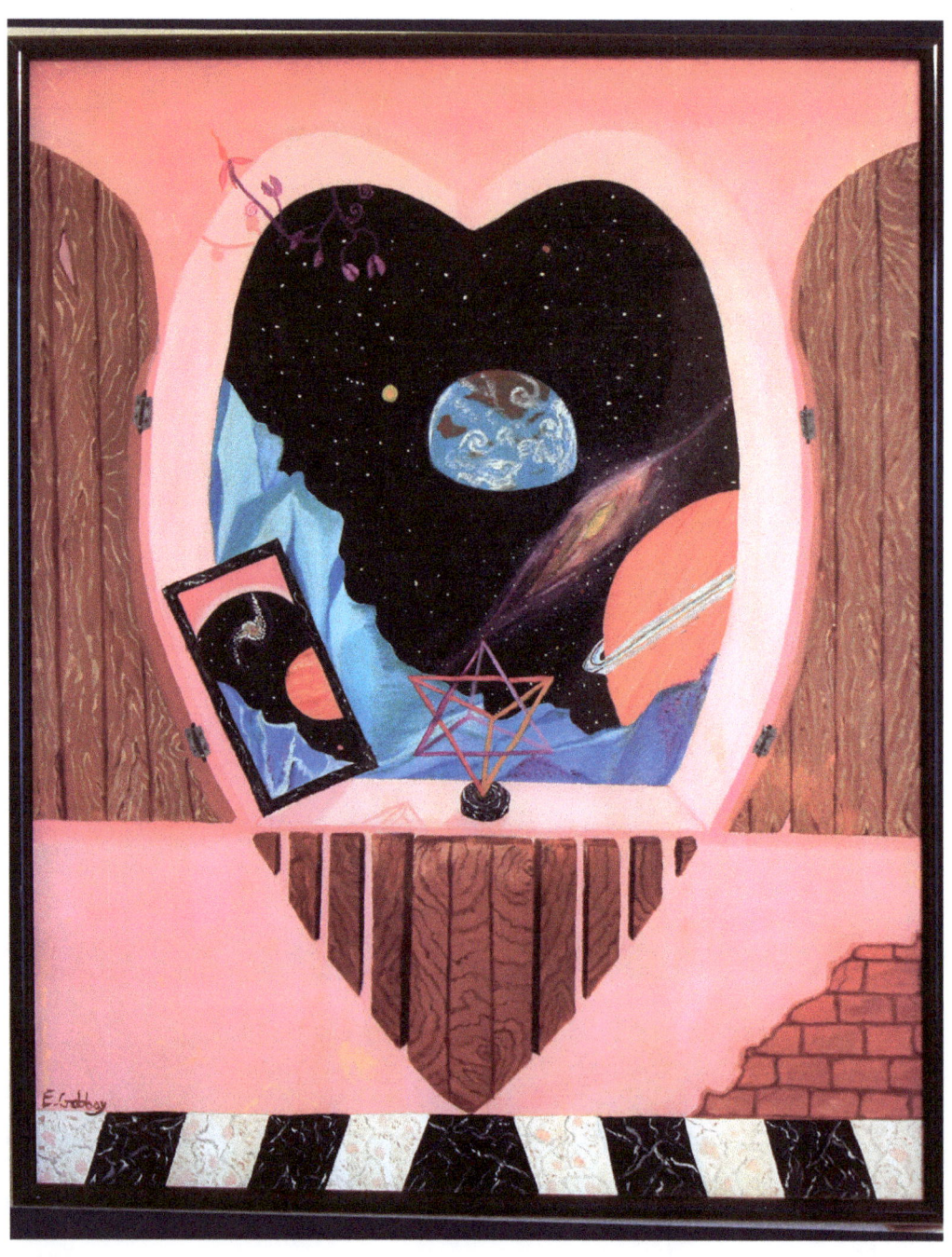

Figure # 53 24-Favorite Planet 24x30

This painting symbolically shows that God is looking down to earth through the window of His house of love that is located on another planet in the solar system. On the window sill is a three-dimensional Star of David representing Israel, his beloved people. I painted the side of the wall unfinished to indicate that God's creation is not complete and is up to us to work on it, with our prayers, learnings, giving charity, etc.

I have always had an interest on Star of David and I incorporated it many times on my paintings. The painting on the cover is 38x38" in size, others are figures # 38, 41, 43, 49, 52, 53 and the painting below.

On this painting I have shown a study of geometry with octagons making up a large sphere and four quarters at the corners. I have three hidden Stars of David in pink and mint colors as you follow the lines.

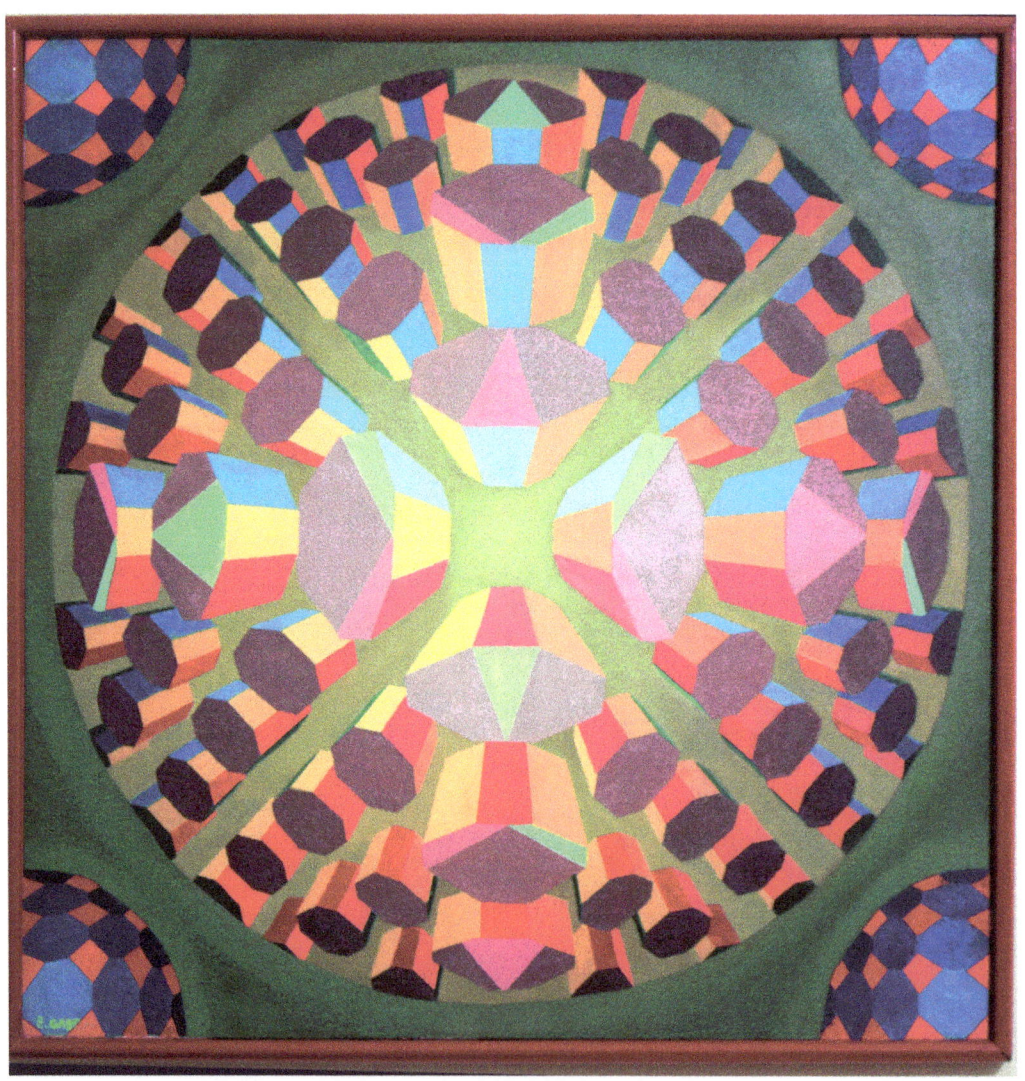

Figure # 54 25-Hidden Stars 30x30

This painting is to the remembrance of Holocaust and all the Jews that lost their lives. I got the inspiration for this work from the movie Schindler's List. At the end of the movie before people were liberated, they were standing in a big room and Mr. Schindler says now we will say Kaddish.

A mourner is standing in the middle of a cemetery saying Kaddish (prayer for the dead) for those who lost. On the right-side, we see the concentration camp in ruin. In the center is the rise of Israel symbolized by the third Temple.

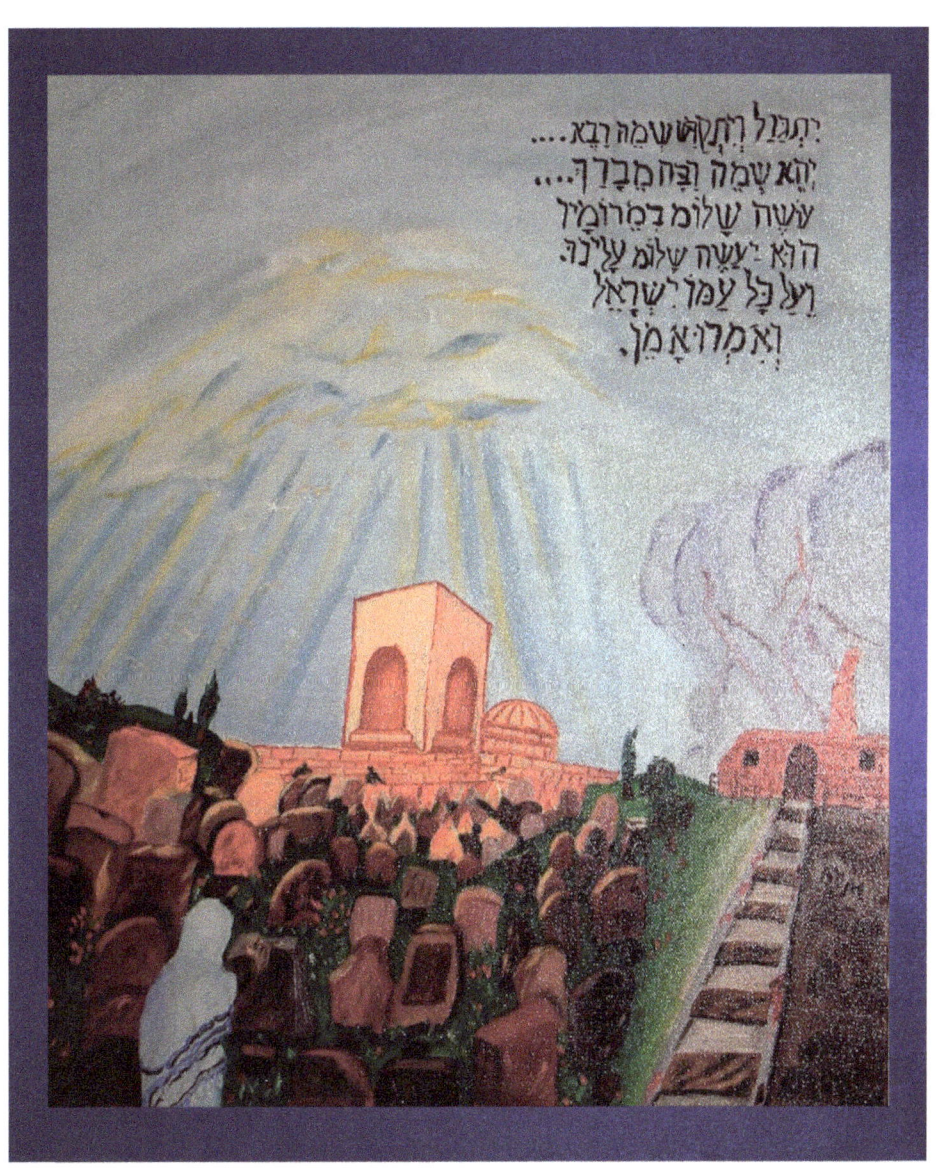

Figure # 55 26-Kaddish

A view from a room in the temple looking out. The golden dome represents Arabs and Muslims overall and the gray towers represent Christianity. The shofar is playing a song for peace on Hanukkah between different faiths but I painted the dove, bringer of peace, transparent to indicate there is no real peace between us.

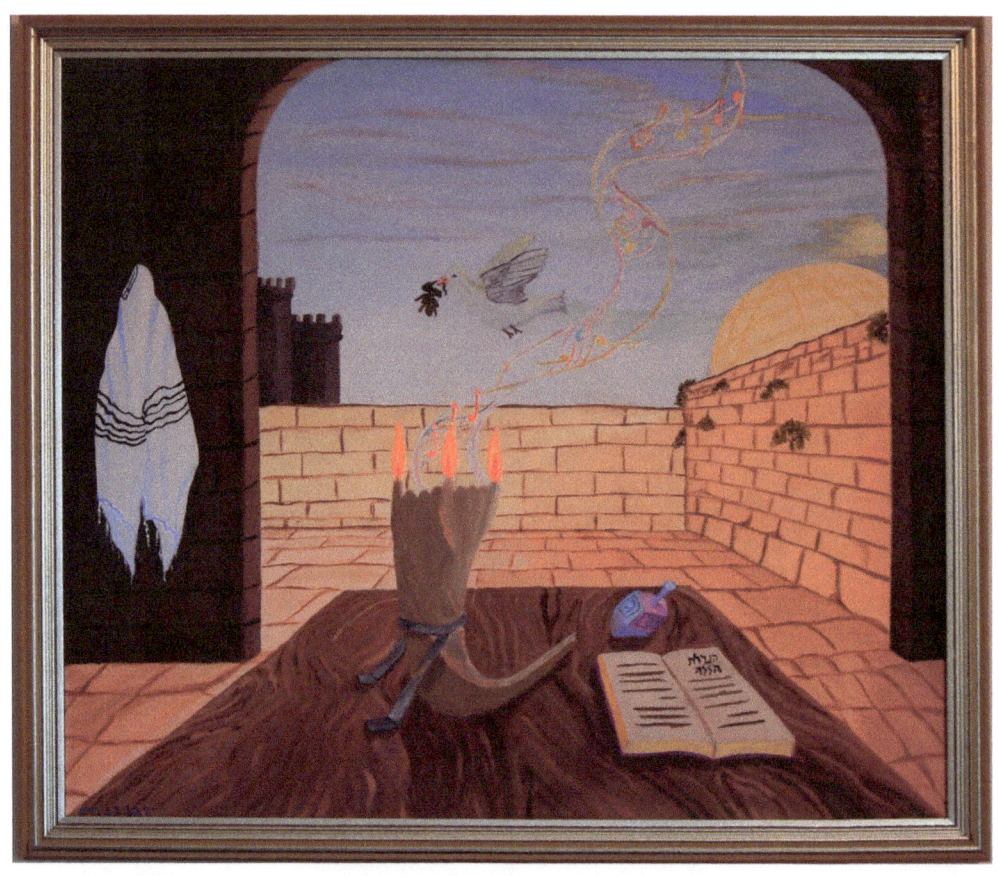

Figure # 56 27-Songs of Peace

I got the inspiration for this work after the tragedy of twin towers in New York city. There are nine palm trees in the picture and the two large ones resembles 9/11. The sound of shofar is indicating a new era in human history; coming of Messiah and rebuilding of the third temple in Jerusalem. Words of Torah is symbolized as water so I painted water flowing from prayer shawl. I picked up a piece from Parsha Ki Sisa when Moses carved another tablet of stone and ascended the Mount Sinai so God inscribed the ten commandments on them. Then Moses proclaimed, "Hashem, God Compassionate and Gracious, Slow to Anger, and Abundant in Kindness and Truth; Preserver of Kindness for thousands of generations, Forgiver of Iniquity, Willful sin, and Error, Who Cleanses—but not cleanse completely, recalling the iniquity of parents upon children and grandchildren to the third and fourth generation."

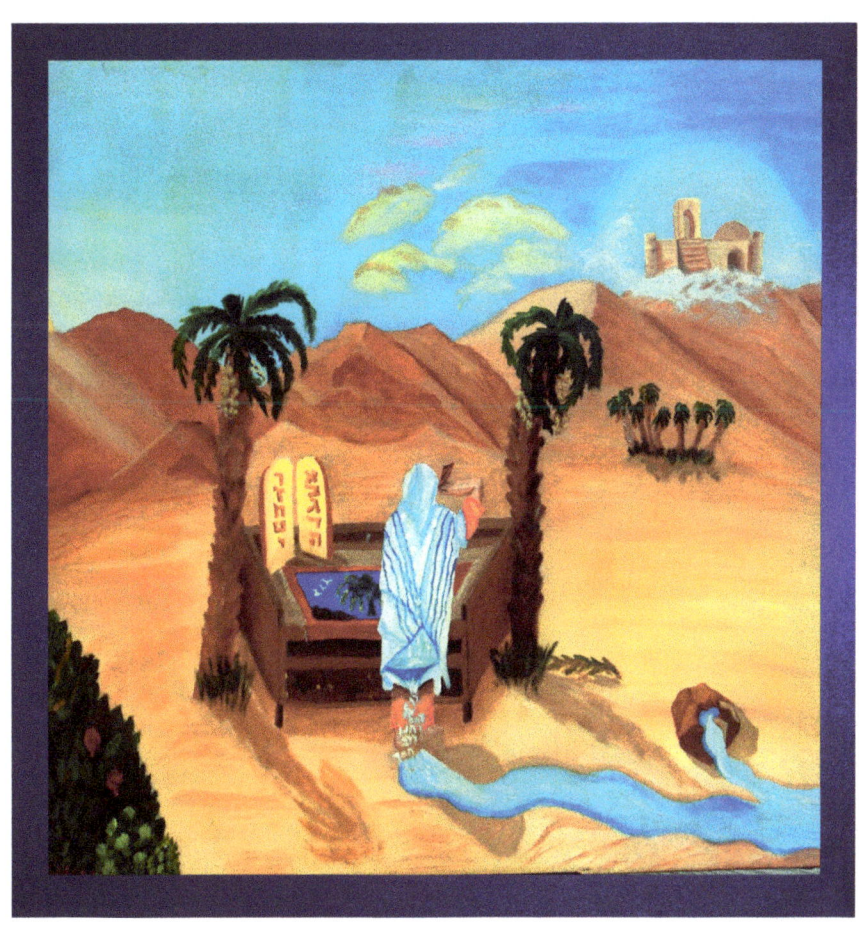

Figure # 57 28-9/11

We all have heard rabbi speaking to bride and groom and their relation with each other using Hebrew words of Ish (man), Ishah (woman), and Esh (fire). Fire happens when their relationship is not peaceful and comes apart.

According to nature and chemistry between a couple, man is represented as the sun, woman as the moon, and natural elements influence their relationships.

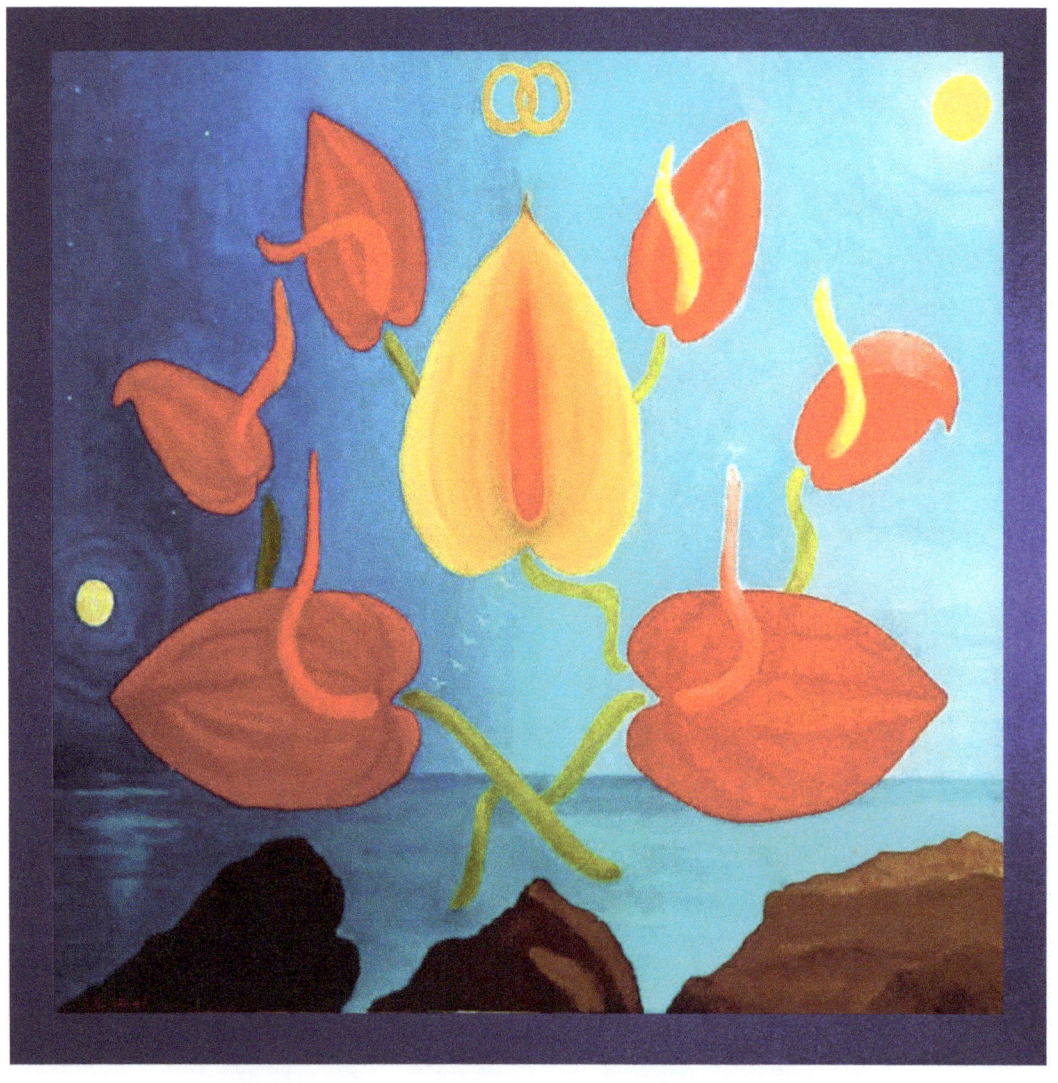

Figure # 58 29-Earth, Wind, Fire, And Water

My vision for this painting is to represent important books and artifacts that every Jewish person should know about and read lots of them. It is a view of the wall through window of a house or a Jewish library. On the shelves from top to bottom are:

First row the five books of Moses and a small Ashkenazi Torah scroll. Second row are some of the early Nevi'im (prophets). Third row Nevi'im, kings, and other artifacts such as Megillah of Esther, Shofar and dreidel. Fourth books of Rambam which are commentaries on the Old Testament. Fifth row books on holy days and few important books on laws of living. Sixth, some important documentary and science books such as Schindler's List, holocaust, and Land of Israel.

Seventh that is mostly hidden under the table are books on Kabbalah because Kabbalah are secrets of Torah and is hidden from regular readers. I arranged the partitions on the bookshelf to create the name of God. It is sunrise, the Tefillin is ready on the table and the Siddur is open on Shema.

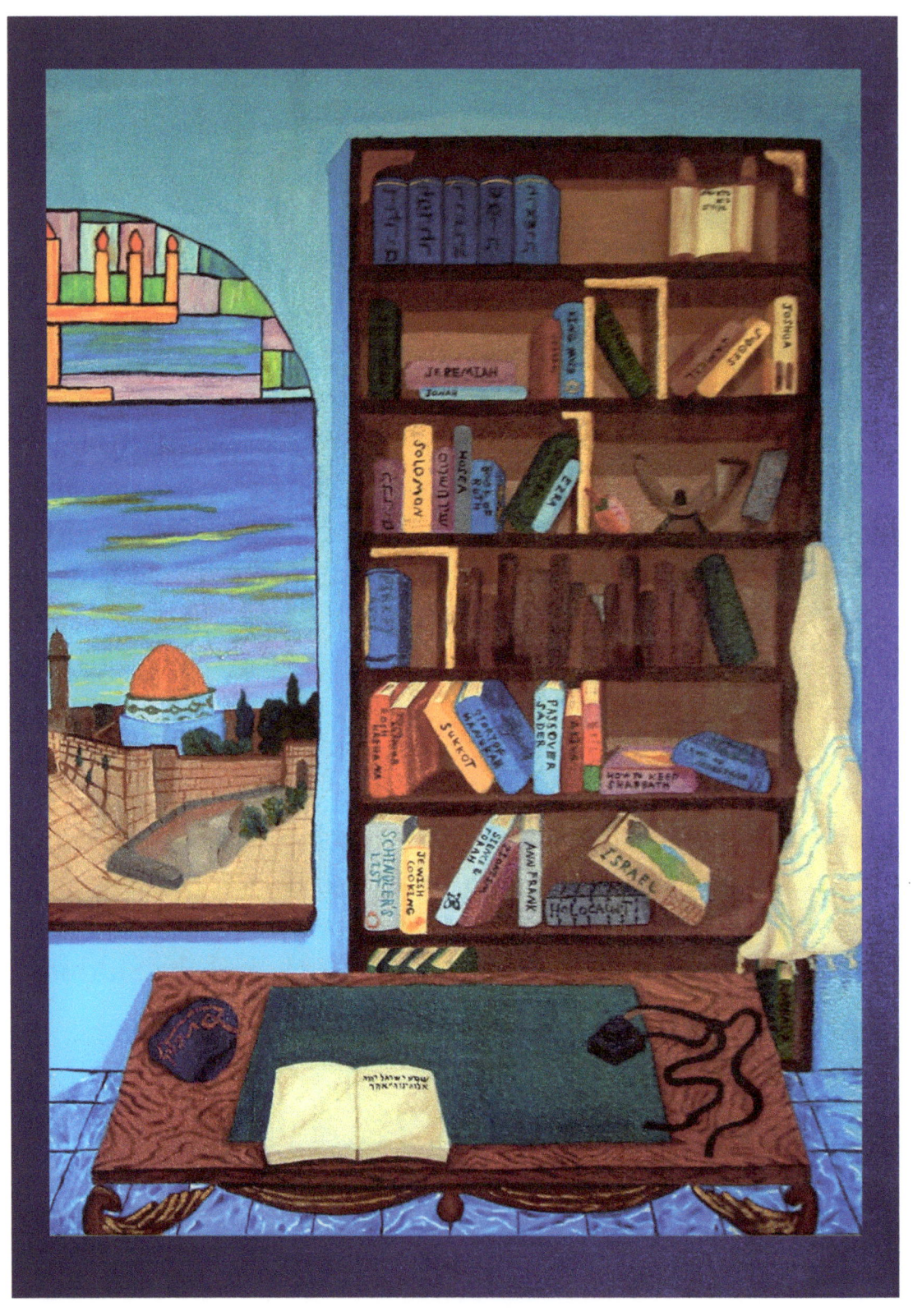

Figure # 59 30- Shacharit 24x36

Wind and waves representing forces of nature are at work and life is balanced on an edge, only through the help of God life flourishes on our planet.

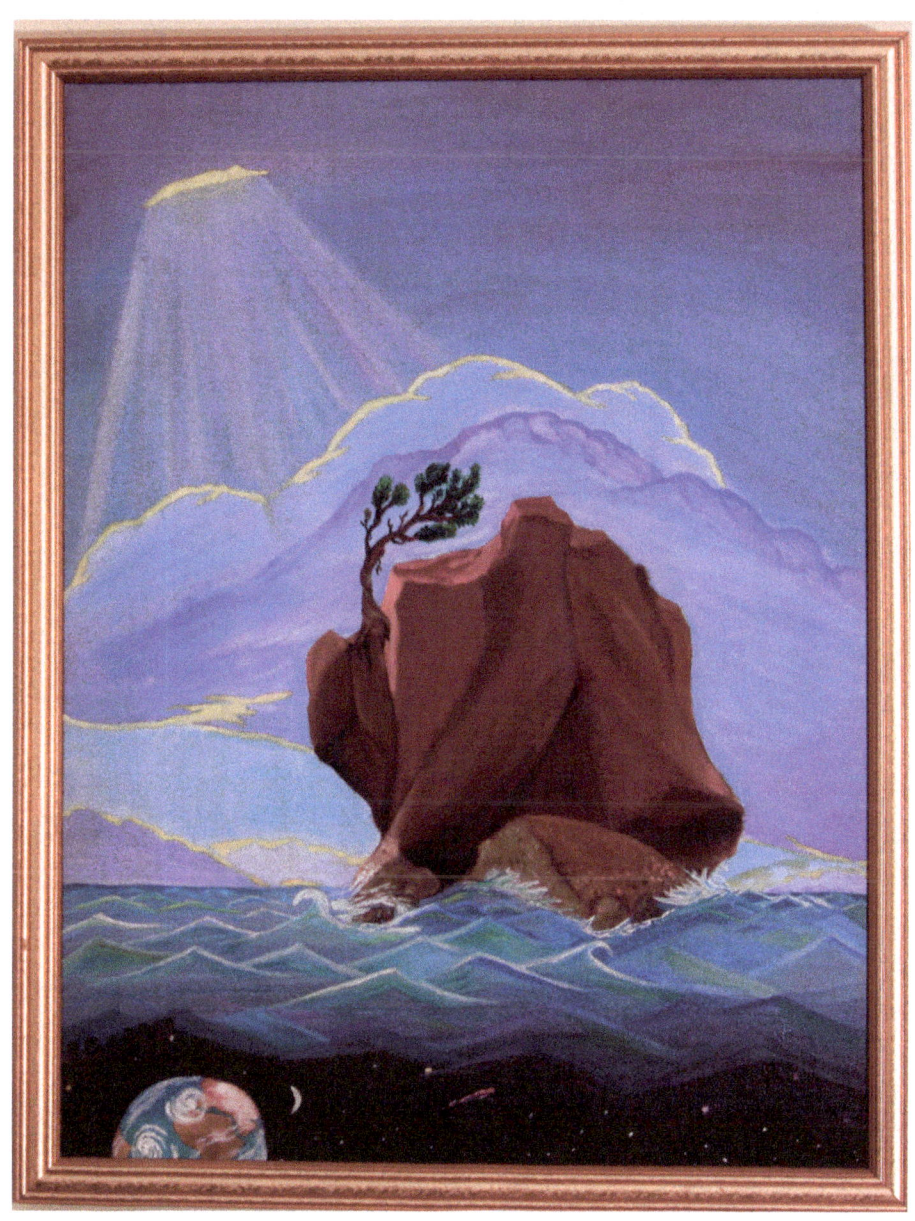

Figure # 60 31-Against All Odds 18x24

This is a very complicated work and the storyline that goes behind it. The inspiration started after reading the book *'An Inconvenient Truth'* by Al Gore.

This works correlates with man as guardian of earth.

"With our actions man plays a big role in mass extinction of animals, birds, fish of the sea, and other organisms on earth. It is time to change our ways and be more responsible toward nature, and diversity of life, and environments on earth." The calendar is on month of November indicating there is not much time.

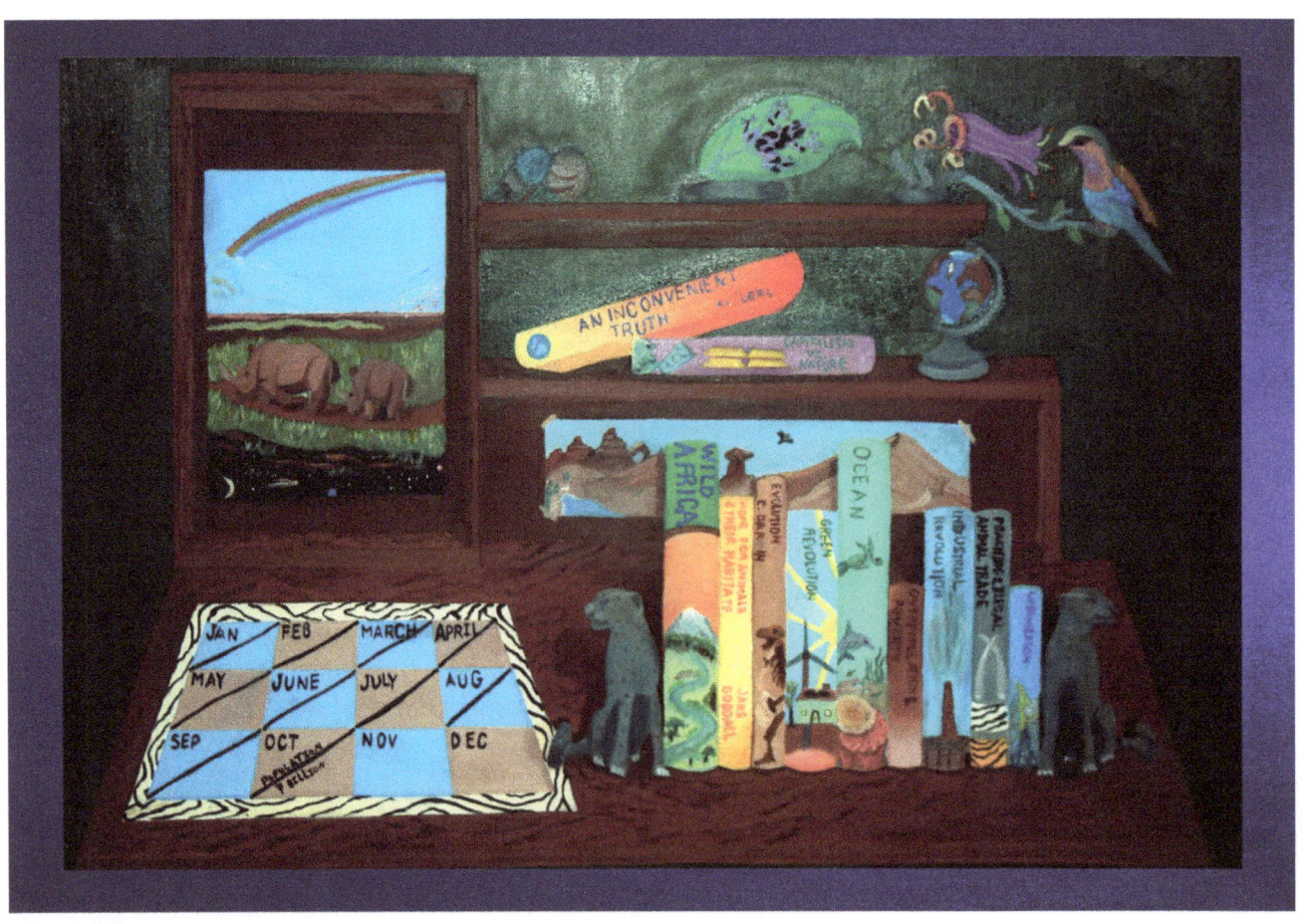

Figure # 61 32- About Time to Turn the World Around 24x36

On October 2014 while I was working on this painting, I find out that the population of the world reached to seven billion. So I added the book "Overpopulation & Poverty" into the design.

The Rhinos are going toward extinction as it is shown, there is empty space under their feet. There is a comparison between a beautiful green environment and a desert. Although we keep the emptiness and ugliness behind, that's why I hid a part of the desert behind books. The choice is ours; having plenty or scarcity.

Books:

1 An Inconvenient Truth: About global warming
2 Capitalism Vs. Nature: As it shows all we care is money and gold.
3 Wild Africa: About nature's beauty
4 Hope for Animals and Their Habitat by Jane Goodall: Success stories about breeding animals back from extinction.
5 Evolution (Survival of the Fittest) by Charles Darwin: Some people believe that extinction is a part of nature and man does not play a role in it.
6 Green Revolution: As technology develops, we have a choice to use renewable sources of energy to improve the environment.
7 Ocean: Beauty of life underwater.
8 Overpopulation and Poverty
9 Industrial Revolution: It was very good at the beginning but companies' greed for more profit and lack of responsibility toward industrial waste had caused pollution in the air, water, and on land.
10 Poaching & Illegal Animal Trade: Killing animal species to extinction for short term profit.
11 Urbanization: cities and buildings should be harmonious with nature. There are a lot of tall buildings in the migratory path of birds that cause countless birds' lives.

This Painting shows our choices. On left-side I have renewable energy and preservation of resources as it shows things are green and growing. On the right-side corporate greed, illegal timber and poaching. Time will tell, the tiger is a witness but greed will kill the witness. The grave stone is for the creatures that are extinct. Baiji Dolphin on the stone used to live in China's rivers but became extinct because of industrial pollution in Yangtze river.

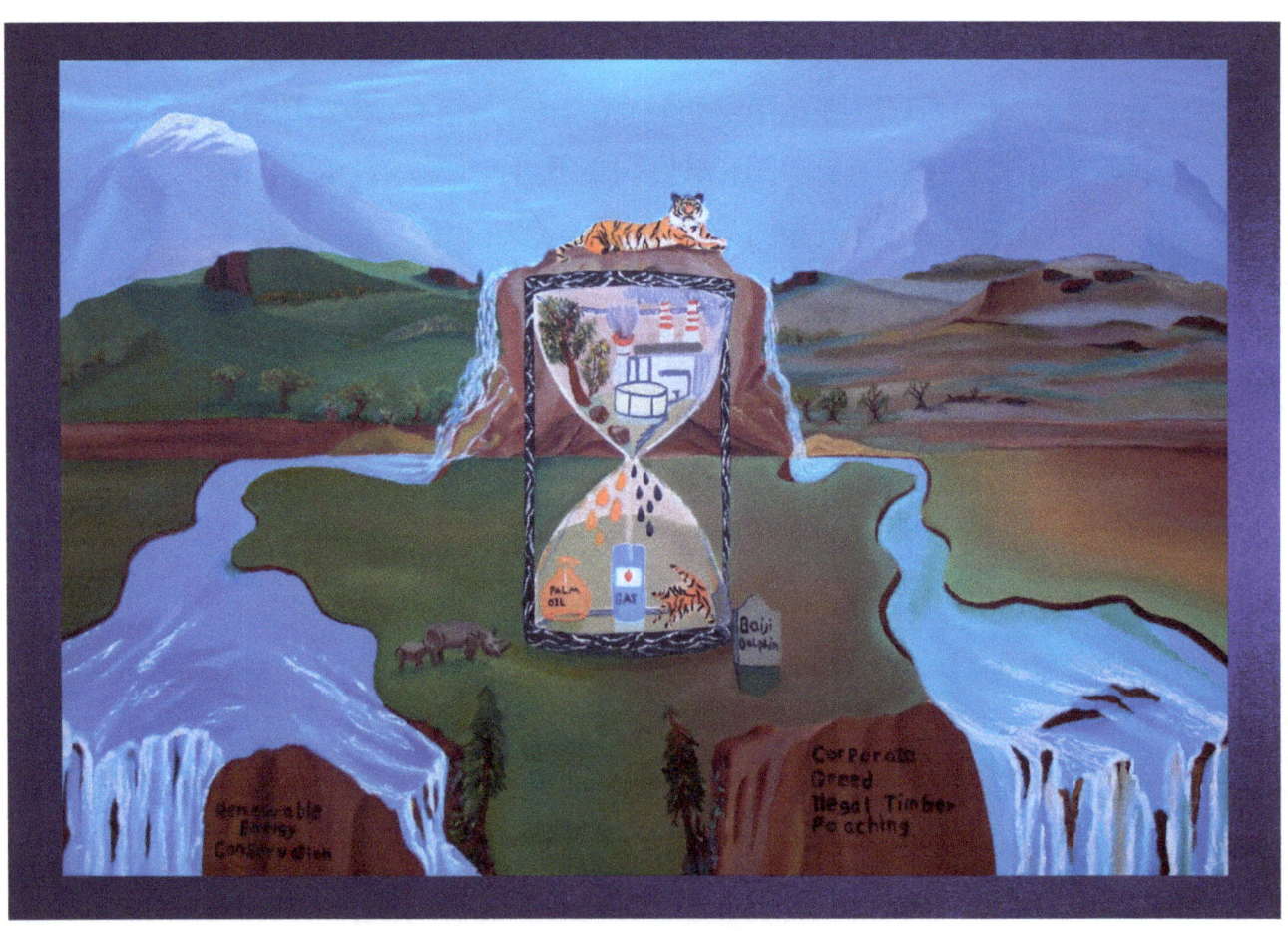

Figure # 62 33- Our Choices 24x36

Conclusion

Throughout most of history, man has lived in harmony and respect for nature.

Beginning with the industrial revolution, urbanization and advances in technology respect for nature, to keep it in a right equilibrium and balance have diminished. Nature have become something to exploit and destroy in our attempt to gain profit and power rather than discovery and appreciation of its beauty. As we have become more dependent on coal, oil, and gas as our sources for energy, we have started to exploit and ruin the pristine nature. By being greedy and looking for never-ending satisfaction of multinational corporations, lots of forests have been raised for production of timber legally and illegally. A big part of Indonesian forest that we haven't yet discovered, some of the plants and other creatures living there are burned for the production of palm oil. We have pushed lots of animals, plants, and other creatures of our beautiful planet into extinction.

Greed and exploitation have caused destruction of the same elements that our life depends on; clean air, clean water, and clean productive soil. Nature's imbalance is turning into climate change with stronger storms, hurricanes, drought on places that used to get enough rain, and more rain on areas that used to be dry. Diseases that used to be local became pandemics. Also new types of illness arose that we never knew about and do not know how to control. Also, by excessive use of antibiotic drugs, we are causing microbes around us to turn into superbugs that are resistant to any type of antibiotics.

I am an environmentalist by heart and worry about the next generation who will inherit this beautiful earth. Will they curse us that we had the opportunity and technology to give them a healthier earth, and we lost that opportunity because of greed for short-term profit?

Back in the chapter of creation, after God created Adam and Eve and put them in the Garden of Eden he said,

"God put man in the Garden of Eden to work it and to guard it."

God has given man powers and the responsibility to carry his wish physically and spiritually. To work and cultivate the garden, meaning to maintain the garden from degeneration and decay. God's creation is still ongoing and it is up to man to make it better with his efforts, physically, and with his worship of God through prayers, spiritually. So, by guarding the garden of Eden means that man should watch it, protect it, and preserve its beauty. Same things apply to our situation on this beautiful earth, we should guard it against exploitation and destruction so our next generations have a better world to live in.

www.ingramcontent.com/pod-product-compliance
Lightning Source LLC
Chambersburg PA
CBHW041921180526
45172CB00013B/1346